HAUNTED
FORT LAUDERDALE

HAUNTED
FORT LAUDERDALE

JOHN MARC CARR

Published by Haunted America
A Division of The History Press
Charleston, SC 29403
www.historypress.net

Copyright © 2008 by John Marc Carr
All rights reserved

Cover design by Marshall Hudson.
All photos are courtesy of the author unless otherwise noted.

First published 2008

Manufactured in the United Kingdom

ISBN 978.1.59629.421.9

Library of Congress Cataloging-in-Publication Data

Carr, John Marc.
Haunted Fort Lauderdale / John Marc Carr.
p. cm.
Includes bibliographical references.
ISBN 978-1-59629-421-9
1. Haunted places--Florida--Fort Lauderdale. 2. Ghosts--Florida--Fort Lauderdale. I.
Title.
BF1472.U6C355 2008
133.109759'35--dc22
 2008005908

For my dad, Francis Joseph Carr,
who loved telling us stories.

CONTENTS

CONTENTS

PREFACE

When I was young, I lived in a haunted house on Long Island. No, it wasn't Amityville. For seven years, I would go to bed with the covers over my head and only a small hole for air. From doors opening and closing on their own to the feeling that someone was sitting beside me in bed, I experienced what it was like to be haunted. My family went through a lot. After seven years, we had the house blessed and I moved out on my own. I thought I would have nothing to do with ghosts ever again.

I moved to Virginia and told my stories of living in a haunted house to those who were experiencing the same things I had endured when I was young. One of my roommates proposed that if he should die before me, he would haunt me, and if I should die before him, I would haunt him. I reluctantly agreed to this pact. I never thought this person would die only seven years after making that agreement.

He haunted me for a year and a half. His spirit would do things that he had been accustomed to doing in life—little jokes like wrapping the shower curtain around me while I showered. I would call out his name and the curtain would release. He would play with the pencils I used when drawing late at night, making them spin, roll to one side and then back to the other. Sometimes he made them fly off the table, just to frustrate me. When I moved from Virginia to Florida, he followed me.

I learned online how to become a paranormal investigator. It wasn't to make lots of money—god knows, I will never get rich doing it—but to be able to let my friend finally rest in peace. After my training was over, I realized I could not do this on my own. I went to New Orleans to find out where my quest would take me.

I had heard that Marie Laveau's crypt was in New Orleans. I went to Saint Louis Cemetery to leave an offering for her and to ask her to help my friend go into the light. I walked around for an hour and found two crypts that had no names, but which were surrounded by many offerings. I left offerings at those locations, and then I finally found Marie's crypt. People surrounded her crypt like they would a movie star or celebrity. I gave my best offering to her—a small bottle of perfume and a dollar coin.

The cemetery was about to close, so I made my way back to my hotel. I took a nap before venturing out to enjoy Mardi Gras. In my dream, three ladies came to me from the darkness of my room. Two of them wore pure white dresses; the woman in the center had a red wrap around her head. She was beautiful. Her eyes met mine and they locked. She talked to me through my mind—I didn't see her mouth move at all. She told me to go to a store located a couple of blocks away from where I was supposed to be later on that night. She even told me what to get to help my friend find his way back through the light.

I woke up in a pool of sweat. I couldn't believe what I had dreamed. Could this be the answer I was looking for? I got dressed and set out to find the store she had described. To my surprise, there it was, a Voodoo Store of Marie Laveau in the same location as in my dream. I went into the store.

I found a couple of items that the dream Marie had instructed me to get. I went up to the counter and said, "You are not going to believe this, but Marie led me to this store." The storekeeper nodded her head and said, "You have a spirit you want to leave?" I was astonished. She told me I had forgotten one thing and gave me the extra candle that I would need to finish my quest. It didn't cost much money. The storekeeper repeated the instructions Marie had given in my dream. When Mardi Gras was over, I went back home to Florida.

I waited for the full moon, as instructed, and performed the ceremony. I told my friend that there was no reason for him to stay with me and urged him to go into the light. He told me, through a voice I heard in my head, that he was only waiting for me. He finally agreed to leave, with the condition that, should I pass, he would come back to get me. He was gone.

I then founded South East Florida Ghost Research (SEFGR) in 1998. It started with a small group of three people investigating local haunts and traveling to haunted locations. I started to post my investigations on the web and received a great deal of attention from other groups who were familiar with the haunts I was documenting. After many investigations, I started a walking ghost tour of Downtown Fort Lauderdale in 2004.

I finally had the chance to investigate one of the most haunted locations in Fort Lauderdale as part of an investigation led by another paranormal group, which lacked equipment and needed additional investigators to collect evidence. After years of conducting investigations in the Stranahan House, SEFGR became the official paranormal researchers for this haunted historical landmark. I was happy to help the Stranahan House conduct investigations and share the information so they could enrich their own ghost tours, which only happen in October.

I hope you enjoy my book, *Haunted Fort Lauderdale*. If you have a haunt that was not included in this book, please feel free to contact me. Happy Hauntings!

ACKNOWLEDGEMENTS

Merrilyn C. Rathbun, Fort Lauderdale Historical Society
Marlene Schotanus, Stranahan House, Director of Education
Diane Cline, Wilton Manors Historical Society, President
Cynthia Thuma, Wilton Manors Historical Society, Vice-President
Benjamin Little, Wilton Manors Historical Society, Secretary
Denyse Cunningham, MA, Broward County Historical Society, Curator
Helen Landers, Broward County Historical Society, Historian
John Heiser, Fort Lauderdale Fire Museum, President
Jim Van Drunen, Fort Lauderdale Fire Museum, Secretary
Doug Reiss, River House, Executive Chef/Operating Partner
The Florida Memory Project, Florida Photographic Collection
Christine Gentry Rodriguez, Portal/ECHO (East Coast Hauntings
 Organization)
Marlene Pardo, Miami Ghosts Chronicles and Florida Paranormal
 Research Foundation
Bill and Lourdes Metz, Paranormal Awareness Society

Special thanks to:
Timmy Dean Patton, my partner in life and moral support for over
 twenty years

ACKNOWLEDGEMENTS

Hilda Carr, my mother
Frank J. Carr, my brother

Members of SEFGR (South East Florida Ghost Research):
William "Tiny" Elrod, Lead Equipment Tech and Lead Investigator
Heidi Ramirez, Historian and Ghost Researcher
Derek Fremd, Videographer and Video Historian
Janeane Wolfe, Videographer and Ghost Researcher
Mark Lewis, Clairvoyant and Empathetic
Lacey Fox, Honorary Member and Ghost Investigator

COOLEY'S MASSACRE

This is the oldest haunt in Fort Lauderdale. It is the story of our first white colonists, as well as a tale of the Native Americans who lived here before the white man came. The Tequesta Indians were the first tribe to inhabit the Fort Lauderdale region. They were hunters and gatherers, unlike the more warlike tribes who lived north of Florida. The Tequestas were a peaceful tribe. According to the Spaniards, who came to Florida in the early 1500s, the Tequestas wore sparse clothing and were not ashamed of their forms—beautiful tan skin covered with tattooed markings. Their jewelry consisted of seeds, shells, teeth, claws and beads. They kept to themselves and rarely traded with the tribes from the north. When the first ship landed on the beaches, the Tequestas were friendly to the Spaniards. But the Spanish did not return their kindness.

The Spanish were looking for gold and the fabled "Fountain of Youth." They took the Tequestas as slaves and gave them diseases brought over from Europe, of which smallpox was the most deadly. The Spaniards had lethal weapons that could kill a person in seconds, and the natives had no defenses against them. By 1763, the Tequestas were wiped off the face of Florida. Those who weren't killed were brought on the ships as slaves. Those left behind slowly died of disease.

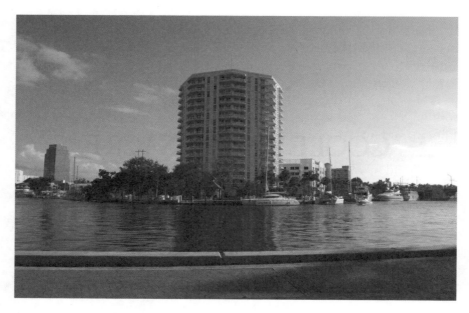

Cooley's Landing South. The plantation house of William Cooley and his family was once located in this area.

Florida was completely uninhabited for over sixty years. The Seminole/Creek tribes were being divided in North Carolina, South Carolina and Georgia by wars with white colonists, who fought and killed them for their land. The natives started to migrate to the northern parts of Florida. They would only come to the southern parts of Florida in the wintertime. Much of the tribal land of Fort Lauderdale was used for temporary winter encampments during the 1800s and into the 1900s.

In 1826, William Cooley moved to the Fort Lauderdale area from northern Florida as part of a military expedition. Originally from Maryland, he was a farmer and a salvager. He purchased a 640-acre plot of land on the New River. His purpose was to grow a crop of coontie. The root, sometimes known as arrowroot, was used to make a starch, which he sold in hundred-pound barrels and shipped north. The Seminole Indians used it to make bread. Cooley proved to be both a successful cultivator and miller, and his business flourished.

In 1835, Cooley became the first lawman and judge in the area, and at this time he made a grave mistake. It is alleged that three white men killed one of the chiefs of the Seminole tribe. Cooley released the men, thus sealing the fates of both him and his family. An uprising had already

begun in northern Florida as the Seminoles fought for land that had been taken away from them. Cooley had formed a good relationship with the Native Americans through trade, and he believed these ties would protect him. This was his downfall.

While on a salvaging trip to the Florida Keys with his youngest son, he left the rest of the family in the care of a private tutor, Joseph Flinton, and two African American servants. His wife, eldest son and two daughters were in good hands. He would only be gone a day or so, and never could he have dreamed what would occur in that time.

On January 6, 1836, the Rigby family—Mrs. Rigby, her daughters and her son—who lived a quarter mile away, had just left the Cooley's property. After arriving safely back home, the young Rigby boy heard noise across the river and ran to the bank to investigate. He returned to his house in a fit, claiming that natives were ransacking the Cooley's plantation. At first, his mother and sisters chastised him for telling fibs, until the sound of gunshots rang in the air. Without further delay, the Rigby family fled southward to the Keys to seek refuge.

The day before the attack, a young native boy named Charley had come to warn Mrs. Cooley. She chided the young boy and did not believe his story, until she heard the yelling of Seminoles arriving on her property, mixed with the sounds of gunfire. The young boy Charley was punished for telling the Cooleys of the plan. The Seminoles cut off his ear as a permanent reminder not to cross them again.

Joseph Flinton was axed to death. His body was then mutilated and his head was scalped. The oldest son and oldest daughter were both shot in the heart—each with a lesson book still in hand. Mrs. Cooley clutched her baby daughter close to her chest. A bullet passed through her baby and then through Mrs. Cooley's heart. The natives took everything they could carry. Everything else was burned, except for the mill, which the natives thought they might need later.

Cooley returned home with his son, only to find that his house had been burned to the ground and his family murdered. He found Mr. Flinton's bloody and scattered body. Word was sent up north to Tennessee, where a battalion of five hundred infantry volunteers made its way down to the New River. In March 1838, a fort was built near the Cooley's property. Commanded by William Lauderdale (hence the name Fort Lauderdale), the infantry's job was to carry out the orders of President Andrew Jackson, further escalating what we know today as the second uprising of the Seminole Indians. Thousands of Native Americans were killed. Those who posed no threat were sent on the Trail

of Tears to Oklahoma as punishment. Many natives died along the trail, as they were forced to walk the long journey and were given blankets that allegedly carried smallpox and measles. By 1842, the war was over.

During my ghost tour, we travel along the New River. We walk along the riverbank as breezes from the ocean greet and cool us. Few realize the horrible things that went on during the earliest part of our history, when thousands of Native Americans died on these banks, and when Cooley and his son returned from the Keys to find a gruesome sight as punishment for letting a Seminole chief's murderers go free.

Cooley's mill is gone. The fort is no more. All that is left are its ghosts.

A view of the drawbridge that connects the north and south sides of Cooley's Landing.

In the early part of January, close to or around the anniversary of the massacre, the ghosts visit us as part of a residual haunting. Many have claimed to hear young children screaming around the property where Cooley's plantation house once stood. The disembodied screams only last for a few seconds, but they will raise the hairs on your arms and the back of your neck in fright.

Once, a scream was heard on my tour, not during the time of the anniversary, but in July. I had a special tour with me that day. A group of Miccosukee natives were part of my tour. There were, I believe, about six of them, all dressed in traditional ribbon shirts, with beautiful long, black hair and the finest Native American jewelry I have ever seen. They were stunning. The tour was going great, until we reached the spot where the plantation house had once stood across the river. As I told my guests the story of how the young children died and pointed to the area where the massacre had occurred, a scream erupted. They all laughed, and one of them said, "You have someone over there to scream as you point." I explained that I work alone and then suggested, "Maybe they think you are Seminole." At first I thought I had offended them, because one of them said something in his native tongue. Their serious faces broke into laughter, and they translated the comment for me: "But we don't look like Seminoles." We continued with the rest of the tour.

If you visit Fort Lauderdale and want to visit the area of the massacre, you can see it from across the river. The actual property is now a condominium complex and is private property, so you cannot walk around. But you can see it if you walk along the riverfront, just past the River House Inn, to the bend where the amphitheatre and the Broward Center of the Performing Arts building are located. The condominium building is round in shape and easy to recognize.

THE STRANAHAN HOUSE

On top of the Henry E. Kinney Tunnel, the Stranahan House stands with its back toward the street. Its front faces the New River, which the Native Americans called the *Himmarshee*. The New River connects to the ocean via the Intracoastal Waterway. This beautiful, two-story pioneer home was the residence of Fort Lauderdale's ferryboat captain, Frank Stranahan. Built by Stranahan and Edwin T. King, this historical landmark was a wedding present for Frank's new wife, Ivy Cromartie. Frank was sixteen years Ivy's senior.

Ivy was Fort Lauderdale's first official schoolteacher, but with the wedding came the end of her official employment. Only unmarried women were allowed to teach, so she had to step down from her position. She would, however, continue to teach Native Americans and African Americans, as that was not against the rules.

There were two original structures that Frank Stranahan built on the property—both were trading posts with large awnings. The large awnings were to house Native Americans who would visit for trading, or for a reading or writing lesson from Ivy. In those days, before refrigeration, one would have to go to market to get fresh food and other daily needs. Although the trading post did provide simple rations of goods and trading materials from the Seminole Indians, who lived across

the bend of the river, its wares were mostly fresh fish, and often what we would term "exotic meats." It was not uncommon to see a turtle for sale on the trading post's front porch.

Before the Stranahan House was built, the trading post was home to Fort Lauderdale's first post office. Frank was the first postmaster. He wore many hats during his lifetime: ferryboat captain, trading post owner, postmaster and owner of Stranahan and Company, which was his second trading post store. In 1926, he was our city commissioner and helped in the planning of our newest fire station, Fire Station #3. Frank's proudest accomplishment was his cracker-style home.

Built in 1901, Frank's Dade County pine home was where people would meet to catch the ferry to Miami. The population was sparse in the 1890s and the weather was very hot and humid. Just getting to Fort Lauderdale was difficult before the railroad arrived in 1893. Before the ferry, if you didn't arrive by boat, you came by stagecoach. The ride to Miami took five hours by stagecoach, two hours by ferryboat and less than an hour by train.

The Stranahan House is now a museum for those who want a glimpse at early nineteenth-century life in Fort Lauderdale. Tours are given throughout the day. Walking through the tongue-and-groove paneled interior, you get the sense of a presence around you. As some say, "You can just feel it as you come through the door." As you enter the dining room through a small trading post room, you find all the places set for an afternoon meal. The crystal glimmers as it catches sun slanting through the frosted glass panels on the front door. To your right is the front parlor, where a fireplace, an old phonograph with a cone-shaped speaker and a piano offer the only forms of entertainment. Bay windows stare out at the moving boats on the river.

Across the hall is the door to Frank Stranahan's office. Decorated with items that would have been sold at the trading post, the room is filled with old pictures, brightly colored native attire, blankets, rattles and dry goods. Toward the back of the house is another doorway, which leads back into the dining area, and the highly polished staircase. At the base of the staircase is a cast-iron safe below a painting of the master of the home, Stranahan himself. You might have the feeling that he is watching you as you pass by. At the top of the twisting staircase, you find the bedrooms, sewing room and the one bathroom in the home.

The upstairs part of the home is decorated with items from the early 1900s. Most of the items were donated to the house by family, friends and

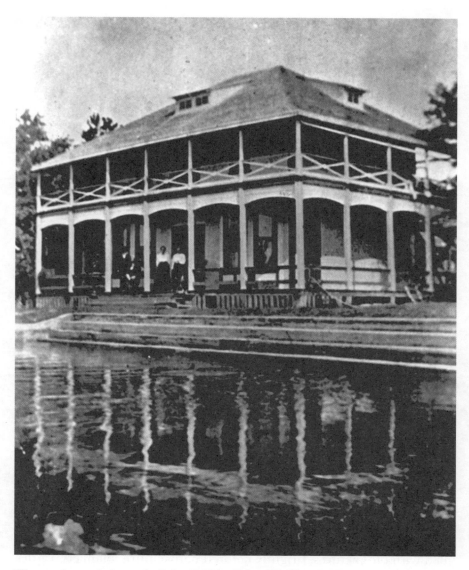

The cracker-style house built in 1901 by Edwin T. King for Ivy and Frank Stranahan on the New River. *Photo by Florida Memory Project.*

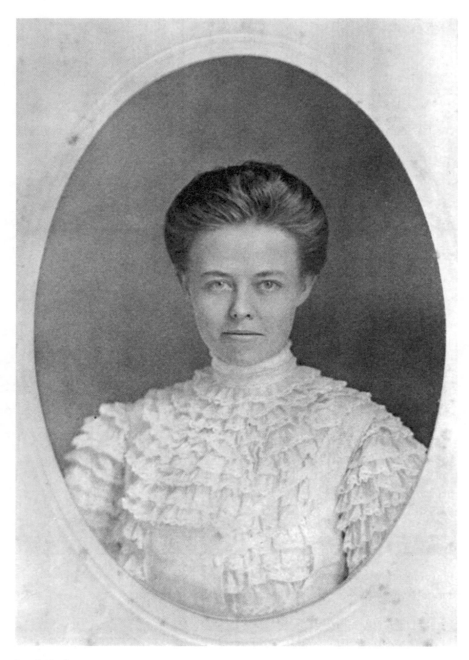

Ivy Julia Stranahan, circa 1890s. *Photo by Florida Memory Project.*

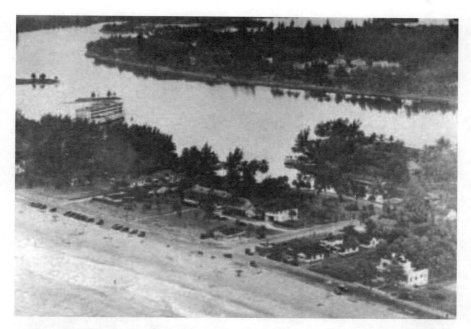

Life on Las Olas, circa 1900s. *Photo by Florida Memory Project.*

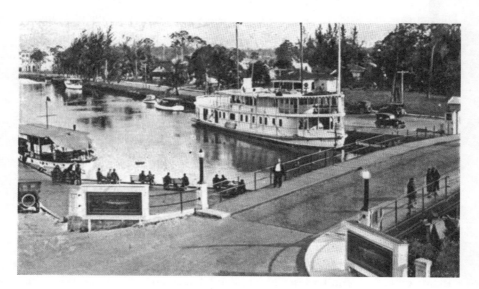

A ferryboat on the New River at the Dixie Highway drawbridge. *Photo by Florida Memory Project.*

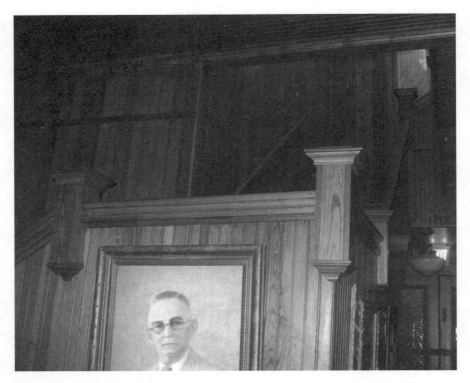

The staircase that leads to the upstairs bedrooms. Notice the painting of Frank Stranahan, done when he was in his sixties.

members of the Stranahan House Organization. Most of the pictures are from Frank and Ivy's collection—Frank was an avid photographer. In their bedroom, there is a picture of Frank's parents, who, at first glance, look rather spooky, a product of late nineteenth-century photography. There is a doorway that leads outside to the wraparound veranda, where Ivy loved to sit beneath the big tree right outside the door. Back inside, the bed is the predominant item of the room. In the corner stands a dresser, housing period dresses. There are usually one or two dresses on the dresser door and one on the bed, as though someone were preparing to go out for the evening.

Across the hall, you find two small bedrooms, each with separate outside exits to a small, closet-like hallway leading to the outside veranda. The room to the left is now the sewing room. Ivy used to sew clothing for the native children who would come to visit and learn reading and writing from her. On the small daybed are two life-sized mannequins of

Ivy and a Seminole boy. Ivy's arm is draped over the shoulder of the young boy as the boy's head arches downward, looking at a book.

Next to that room is the guest bedroom, which is called Albert's room. Albert was Ivy's youngest brother, and this was his room for a short time in the early 1920s and '30s. As you walk in, the bed is to the right with a nightgown lying on it. To your left is a small dresser drawer, above which is a hat rack and mirror. Toward the back of the room, on the left, is the door that leads to the small, closet-like hallway to the veranda. On the veranda there is a stairway that leads to the first-floor wraparound porch.

In between the master bedroom and the smaller rooms is a hallway with three small steps. Immediately to the right is a short staircase leading to the attic. There is no banister, and the stairs are quite small in order to fit in the narrow hall. At the top of the stairs is a door with a hook latch for entrance into the attic. Farther to the back of the hall is the bathroom, with a white, cast-iron, footed bathtub below a frosted glass window. A pedestal sink is to the left, with a small medicine cabinet and mirror door. Inside you find products from the 1930s, as if everything had been left in its place.

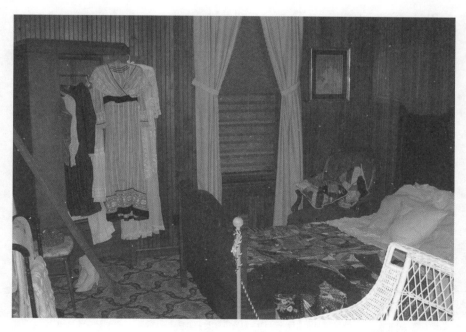

Ivy and Frank's bedroom. It always looks like someone is getting ready to go out on the town.

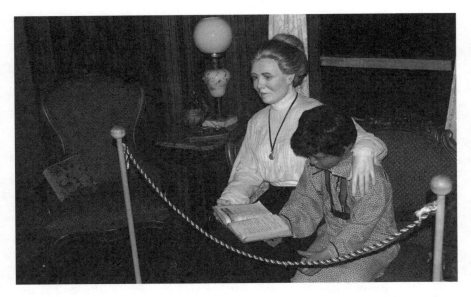

A mannequin of Ivy teaching a young Seminole boy. This always shocks people as they walk past the small guest room that was turned into a sewing room.

Back in the hallway, to your right, is another larger guest bedroom. This extension of the house was added in 1913. The house was also given a newer gift—the gift of electricity and indoor plumbing. Now the gift shop, this bedroom was originally used for guests and family, and occasionally Ivy rented it out to boarders to make some extra money. The gift shop sells replica jewelry, postcards, books, toys and even soaps and trinkets as souvenirs.

THE GHOSTS OF
THE STRANAHAN HOUSE

Throughout my career as a ghost tour guide, I have fielded many questions, like: "Why do you think so many people died in this house?" I always enjoy telling the truth: "Because people back then didn't die in hospitals, they died in their homes."

The Stranahan House has six known ghosts. Each has his own story of how he lived, how he died and now, how he haunts the Stranahan House. Why the ghosts stay in the house is a question that we ask during every séance, but at the requests of the ghosts, it is one we will no longer be asking. They are a family, in life and in the afterlife. They remain in the house because they choose to—one thinks he has no choice and the others stay because of him. The family bond goes beyond life itself. These are their stories.

The first ghost has the earliest death recorded on the premises. It happened in 1903. A young native girl walked up to the house and knocked on the front door facing the river. She entered the house, and for unknown reasons, fell to the floor at the threshold. At first, Ivy was saddened by the event, but then she became frightened. She thought that the natives who lived across the water would think she had killed the child. She wrote in her journal, which she probably left out for Frank to see, that "a young native girl had passed away in our

doorway." She mentioned later that a native friend named Squirrel took her and the girl's body across the river.

During my first exploration of the Stranahan House we had a couple of investigation groups at the location in order to make use of a greater amount of equipment and to get the work done in a fast, orderly manner. During my investigation, my electromagnetic field (EMF) meter was sounding off in the doorway. I took out dousing rods and there was energy moving back and forth, as though a child were running up and down a narrow path. At some moments the energy would stay still over a chair at the end of the hall.

One of the investigators was Lacey Fox, who was no stranger to the Stranahan House. She had been there previously with another group of investigators, but now was flying solo. She had an analog tape recorder, which she turned on and left on a rocking chair that was known to rock on its own. I heard a *tha-thunk* and asked, "Did somebody fall in here?" I continued to get EMF readings in the hall by the door—they would get close and then move away, like a child at play. The following day, Lacey called me, excited about the electronic voice phenomena (EVPs) that she had collected on tape. She needed a way to clean up the sound, so she came over to my place to see what could be done.

After downloading parts of the tape to my computer, we were able to clean up certain sections. We heard my voice ask, "Did somebody fall in here?" Right after that, the distinctive sound of a young girl's voice responded, "Meeeee." Lacy and I looked at each other. There had been no young girl in our group. The same young voice made a number of different sounds through the microphone on that analog tape, sounds of short singing or chanting. We were quite happy to have collected the first sounds of the spirits of the Stranahan House.

The young native girl loves candy as much in death as she did in life. Jars of candy kept in Frank's office are often found with the lids off. The candy is later found all the way up in the attic space. John Della-Cerra, the caretaker of the property, finds the candy when changing the air condition filters. The candy is always in a pile in the corner of the attic. John checks for teeth marks, suspecting mice—or worse, rats—but no marks are ever found on the treats.

The second ghost died in 1926. Pink Cromartie Moss was pregnant with her third or fourth child. All her previous pregnancies had ended in miscarriage, and this time her husband, Randle, was up in New York or New Jersey for business. He bought and sold real

estate. Since he wasn't in town, Pink was staying with her sister Ivy. She stayed in the parlor room, which is located toward the front of the house. She was instructed not to go up or down the steps to the second floor, given her previous troubles with childbirth. All her days and nights were spent in the parlor room.

One day, during a dinner party, guests who were from out of town found out that not only were Pink and her husband not legally married, but Randle also had another woman in New Jersey. This upset Pink, and in all the excitement, she went into early labor. Only seven months into the pregnancy, she was instructed to lie down and rest. When her family and friends came back to check on her, she had an infant in her arms—it, too, was stillborn. Frank was instructed to bury the infant in the woods. Pink was bleeding a lot and they wanted to take her to the hospital, but she refused. She died of a hemorrhage in the parlor.

When we do investigations in the house, we like to hold a couple of séances. One of our favorite places is the parlor. During one of our investigations, the spirit of Pink came into the parlor. On my digital recorder, we could hear her announce in a whisper, "I'm here." She refused to talk about the baby. She only wanted to speak to a man named Clark, who we found out was the sheriff at the time of her death. My only guess is that she is still trying to turn in her two-timing husband to the police. While her spirit is in the room, we sometimes observe orbs flying around. Often there is a larger orb with a smaller orb attached. We assume that it is Pink and her baby, forever bound in the afterlife.

The third ghost is significant. In 1926, a big hurricane came through the Fort Lauderdale area. Frank had several businesses just starting to blossom. He had banks, a small field of citrus fruit and he was offering financial help to a furniture store, Stranahan and Company, which he had started but later sold. All was washed away during this devastating hurricane. Then came 1928, and the Great Depression hit. All the money invested in the banks he had started was gone. If that wasn't bad enough luck, he began to get sick. He had severe pains in his groin area. He went to a hospital and was diagnosed with prostate cancer. The doctors told him there wasn't much they could do for him and gave him palliative drugs to ease the pain. They instructed him to divide his property and belongings, say goodbye to his loved ones and make amends with his enemies. He would be dead within six to twelve months.

Frank was devastated. He faced the difficult task of going home and telling his wife. Everything he had worked for would be lost. He found a tray of medicine and tried to commit suicide. The hospital found him, pumped out his stomach and put him in a sanitarium.

Poor Ivy was very upset by the news of her husband. Every day she would write to the sanitarium, begging them to release her dying husband. He only had six months to live and she wanted him home so she could take care of him in his hour of need. After six months, they finally released him. Ivy had to pick up Frank from the hospital and drive him home.

One day, after a drive to the beach, Ivy and Frank had an argument. As they approached the house, Frank noticed they were working on the sewer lines in front of his house. He made his plans quite quickly. They entered the house and Ivy went upstairs to change. Frank went outside and got a wheelbarrow. He went to the city street and got a sewer grate, put it into the wheelbarrow and dumped the grate at the riverfront. He went inside, and while Ivy was still changing, he found a ten-foot chain. He went back outside and attached the chain to the sewer grate and threw himself in the river. At the water's edge the river runs twenty feet deep. Frank's brothers-in-law, Albert and Bloxham, were there fishing, and they threw in their poles to try and help him. After a struggle and several rescue attempts, Frank drowned.

It took two hours to retrieve Frank's body from the river. A firetruck, ironically the "Frank Stranahan Firetruck," was called out with a winch to extract his body, which was stuck to a reef along the property.

Fort Lauderdale was in shock—it had lost its father. Frank had been called "White Father" by many of the natives in the area. Poor Ivy was devastated as well. With the loss of her husband, there was no money coming into the house. Suicide meant she could not collect any type of insurance. After talking to a lawyer friend of hers, she decided to take on boarders.

Frank is the third ghost. He is a residual haunt that occurs at the edge of the property. From time to time, people have seen a man jumping into the river. The man is always dressed in white. As he falls into the river, there is no splash. He is said to be committing suicide over and over again. His ghost is bound to the outside of the property. He was the son of a minister, so committing suicide was a step toward binding his soul to this world. Fearful of what judgment

he might receive on the other side, his spirit will not follow the normal progression into the light. He has turned his back on the light and refuses to cross over.

The fourth ghost is an angry ghost. He is the closest thing the Stranahan House has to a poltergeist. He is angry because we are alive and he is dead, and he carries around a great deal of resentment.

Albert, Ivy's youngest brother, was part of Frank's attempted rescue. After his brother-in-law's death, he decided to be one of Ivy's newest tenants. His room had a separate entrance into the house, so he could come and go as he pleased. During Prohibition, a new neighbor, Alfonso Capone, moved in. Albert was in his twenties and always looking for entertainment. He frequented the speak-easy that sold spirits smuggled to Fort Lauderdale by Capone's henchman "Machine Gun" Jack McGurn. Capone also purchased bottled spirits from the islands off the Florida shoreline, like Cuba, Jamaica and Puerto Rico. Fort Lauderdale became known as Fort Liquordale. Capone put everyone on his payroll, corrupting the city with alcohol and prostitution. Albert was having a ball.

Then, one day, Albert developed consumption, or tuberculosis. He contracted it from one of the girls at the brothel he frequented. He was quarantined to his room and was not allowed to leave the premises. With tuberculosis in the late 1920s, you either lived through it or died from it, and little could be done to influence the outcome. Albert died of respiratory failure within six months.

His spirit is sometimes playful, sometimes angry and sometimes perverted. If a man he doesn't like enters his room, he will make the room ten to fifteen degrees cooler. On occasion, he will move objects to scare a person away. If the person is a woman, he might make the room hotter. Women will sometimes get the feeling that someone is watching them, even when they are alone. His bed sometimes looks like someone has slept in it in between the tours, and he has been known to touch ladies in forbidden places.

During one of my investigations, Albert left me an EVP. We were trying to get him to move on because the workers were feeling distressed by his playful behavior. During a recitation of the Lord's Prayer, he said, in an angry, gritty tone, "You need suffrage." He has also been known to say, "Get out!" or playful things like "I am the wind."

The fifth ghost is one of the quietest spirits, Augustus Cromartie, Ivy's father. He went to her in the final weeks of his life. He was dying

of pneumonia and he wanted to spend his last days with his daughter. Ivy put him in the new guest room on the second floor, toward the back of the house. He died uneventfully of respiratory failure in his sleep.

His spirit is rather quiet, until you mention Ivy. He has been known to knock over a book or a toy at the sound of her name. His room is now the gift shop, and he doesn't like change. He will make the room cold if you move something out of place. The ladies who work in the gift shop are prone to feelings of being watched when they are alone in the room. Once, he took a book and threw it three feet toward three of my investigators. It landed harmlessly in front of them but gave them quite a shock.

The sixth and final ghost is, of course, Ivy. Ivy died in her sleep in 1971 at the age of ninety. She had her wits about her until the day she died. She was the president of the historical society until her death. She died in the same room as her father, as she had a boarder at that time. (She could make more money renting her own master bedroom.)

Her spirit is lively. At the mention of her name, you can sometimes smell the stale scent of sweet peas or lilacs. She has been known to bestow a warm feeling upon those she likes and she blows in the ears of those she doesn't like—like a schoolteacher watching you cheat on a test from behind. She sometimes enjoys rocking in her favorite chair by the fireplace in the living room parlor. Sometimes people say they hear the footsteps of a lady walking up the stairs. We assume it is Ivy making her rounds. She has also been seen outside at the back of the property, where her garden used to be.

If you are ever in Fort Lauderdale, I encourage you to visit the Stranahan House and perhaps you will have your own ghost story to share as a souvenir.

SMOKER PARK

There is a park directly across from the Stranahan House looking over the New River. The area was first inhabited by the Tequesta Indians. When the Spanish forced them off the land, remnants of their village were left behind. Seminole Indians finally traveled down in the late 1700s and used the area as a winter campground. They took up temporary residence where the Tequesta natives once lived. They continued to winter in the area, and in the early 1800s, they witnessed the earthquake that created the New River.

Their stories were once conveyed by their ancestors to Mrs. Ivy Stranahan. According to the stories, one morning the natives were awakened by the sound of loud thunder beneath their feet. They came out of their longhouses to find the ground cracking in the middle of their village. From that large gap, water sprang up and created a river. The Seminoles called it *Himmarshee*, which means "New River." The river's water ran down to the ocean, and with the tides of the ocean, the once fresh water turned brackish. We now assume that one of the five aqueducts, located six to ten feet below our coral shelf, must have cracked with the earthquake and provided the water to fill in the gap. The Seminoles were delighted by the gift of this river and thought it was a sign that their gods were pleased they had moved to the area.

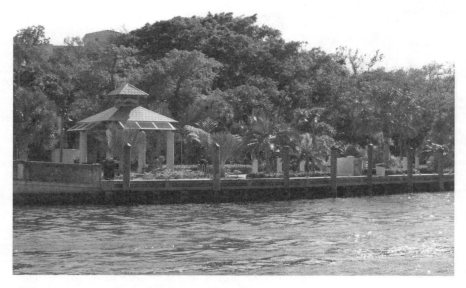

A view of Smoker Park from the Stranahan House.

In 1899, the growing white population in Fort Lauderdale began developing the land. Ivy's first schoolhouse was built. The Kings (Edwin T. King) developed the land into homes. The former winter campground of the Seminoles was getting smaller and smaller. In the 1920s, the Seminoles left the area, leaving behind the remnants of their villages. During the 1970s, developers purchased part of the land and proceeded to remove some of the houses. Hence, the King Cromartie House was moved, via a barge on the New River, to the historical village near the New River Inn.

In the year 2000, developers planned the destruction of David Oliver's home. Oliver was the first treasurer of Fort Lauderdale, and his home was considered historical because it had been designed by Francis Louis Abreu. Nolan Haan purchased the home for only $25,000 and moved it to Sailboat Bend.

The land was to be made into a large apartment complex right on the New River. People in town didn't like the idea of the development, which included the removal of a tree that was over two hundred years

The large, two-hundred-year-old tree in the middle of Smoker Park.

old. An archaeological dig was taking place and a protest ensued. People allegedly chained and handcuffed themselves to the mighty tree, only to be told that their efforts were unnecessary. It turned out that the archeologists had uncovered a Native American burial site and the development was scrapped.

Smoker Park was born, and it included a conservation area. Under the shade of the two-hundred-year-old tree, this park was used as a docking station for boats and small yachts. Vagrants would sometimes make small camps in the darkness under the brush and in the shade of the majestic tree. They would never stay long. That would be the first sign of the haunting of Smoker Park.

According to the rumors, vagrants were awakened in the middle of the night by unseen forces poking their ribs or shaking their shoulders in the darkness. Thinking it was the police with their night sticks, the vagrants would rise. As they opened their eyes and came to, they would find no one there. Occasionally they would hear whispering that they could not understand. A chill wind would make the hair on the back of

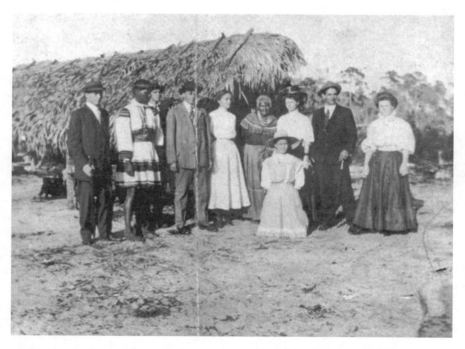

Visitors to Seminole winter campground in Fort Lauderdale, circa 1909. *Photo by Florida Memory Project.*

their necks stand on end. They sometimes heard phantom drumming in the darkness. They would gather their belongings and flee the property, never to return again.

In 2004, the park was given a makeover. A new brick walkway and driveway were built. The docking area got new hookups for water and electricity for the yachts and boats, making it a perfect place for snowbirds to come and stay. The boaters would rent the docks for their long or short stays along the river. A new gazebo was the focal point, where people could sit and watch the boats float by along the narrow bend of the river. The big tree still stood, with all of its twisted branches, looking a bit less ominous alongside the fresh beds of flowers and edged walkways.

SEFGR, Portal and Miami Ghosts went to the park when the park renovations first began. We did this right after I conducted a tour. We entered the park with our EMF detectors (gauss meters) in our hands. We separated with the hope of making contact with the spirits inside the park. If one of our gauss meters sounded, we would take a picture of the person whose meter went off. Each picture we took in this manner showed an orb around the person in question. The park was dark, and the electricity had not yet been installed at the construction site. We also took pictures of people whose meters didn't go off, to

The gazebo and brick walkway after the 2006 renovations.

prove that the orb phenomenon only happened in cases where the meter sounded.

I remember a chill that made the hair on my arms stand up, and I heard whistling sounds even though there was no wind. The darkness was so thick that, at one point, I couldn't see my hand in front of my face. The only light we could see appeared when someone snapped a picture of the surrounding area. The big tree limbs were twisted and some had replanted themselves in the ground. With each flash, the limbs took on a life of their own. Some looked like arms, others like legs and knees stemming from the ground. I shook off the illusion that body parts were protruding from the earth with an internal voice, repeating to myself, "It's only a tree. It's only a tree." The tree held orbs like ornaments in its branches. The orbs would move and change position with every picture.

We could not do EVPs due to the river. A wandering boat would come by and the occasional glee of the boaters' whoops would have made it difficult to hold a proper séance or vigil. Someday I would like to try to conduct an EVP session in the park, but it would have to be in the wee hours of the morning to eliminate the sounds off the river and noise from the tunnel's entrance at the southern end.

Since my investigation, I have been contacted by many people who tried to spend some time in the park late at night. I often suggest that they take several pictures of the tree, and once an orb is found, continue taking pictures as they try to encourage the orb to come closer. People would email me with their results. Some could not believe what they were viewing. A ball of light would slowly come down from the tree limbs. The orb, which could only be viewed on the LCD screens of their digital cameras, would get closer and closer. Many would run out of the park afraid of the unknown phenomenon and what it could do to them.

Smoker Park is open to the public daily and doesn't have any gates to keep people out of the park. Signs do say that the park is closed between 4:00 and 6:00 a.m. This is to discourage people from sleeping in the park, though it seems that many vagrants have learned not to sleep in the park on their own.

THE HENRY E. KINNEY TUNNEL

In 1956, a young editor/journalist for the *Miami Herald* (Broward edition) reached his final straw while waiting forty-five minutes for a two-lane drawbridge to open and close on the major highway, Route 1, to Miami. His name was Henry E. Kinney. He was furious that he was often late two to three times a week and took it upon himself to lead a crusade to have the bridge torn down and a tunnel built in its place. In 1956, opponents like Florida Governor Gore and the *Fort Lauderdale Herald*'s editor Carl Weidling Sr. wanted to create a high-level bridge that would not have to open for boats traveling along the busy New River. Mr. Carl P. Weidling was Fort Lauderdale's first attorney, and in 1913 he established the *Fort Lauderdale Herald*, which was the second newspaper in town. Henry E. Kinney didn't agree with the high-level bridge idea, and he circulated a petition for the construction of Florida's first underwater tunnel in Fort Lauderdale.

Mr. Kinney used his influence and wrote articles that promoted his side of the debate. The *Fort Lauderdale Herald* took the opposing view, which contended that the tunnel would cause economic damage to Fort Lauderdale's Las Olas Boulevard. In November 1956, a vote was held and the pro-tunnel group won, 7,008 to 6,401. The *Miami Herald* celebrated victory, while the *Fort Lauderdale Herald* aired its disappointment.

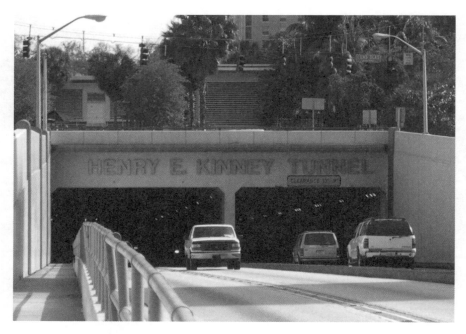

The entrance into the Henry E. Kinney Tunnel, north side.

In August 1958, construction of the new tunnel began. The Stranahan House is the only structure that the tunnel had to support above ground. The rest would be the road—Las Olas Boulevard and its cars. Ivy Stranahan was not in favor of the tunnel, and every time dynamite exploded, she would report another broken dish. She had an awful time during the construction of the new tunnel. Dynamite had to be used to get through the coral shelf six to ten feet below ground. It took a very long time to complete the tunnel. Piles of dirt were placed in front of Ivy's house. Some of the neighbor kids would stay and watch as the construction of the tunnel progressed.

On December 9, 1960, the tunnel was finished, at the final cost of $6.6 million. Governor Leroy Collins cut the ribbon to Florida's first underwater tunnel. The tunnel was called the New River Tunnel. For Ivy Stranahan, it marked the end of street traffic in front of her house, which used to be Route 1, Federal Highway. As predicted by opponents, it did have a negative effect on business along Las Olas Boulevard and the now defunct street. As for Ivy, the tunnel brought with it nostalgia for the days when her family and friends would drive past her house and honk their horns as she sat in her favorite spot beneath the tree on the second-floor veranda.

The Henry E. Kinney Tunnel

In July 1985 Henry E. Kinney died. In a legislative session held in 1986, the tunnel name was changed from the New River Tunnel to the Henry E. Kinney Tunnel. It was dedicated to the man who fought for Florida's first underwater tunnel to be built here in Fort Lauderdale.

The tunnel, however, has not been free of problems. It has been closed numerous times to fix leaks in the four-lane structure. Most work on the tunnel is done at night, but there have been times when the tunnel has been closed for days for repairs. Those who use the tunnel to get back and forth to work feel the sting of what Henry E. Kinney experienced as he waited forty-five minutes for the old drawbridge to open.

From the beginning of construction until the death of Henry E. Kinney, there were no reports of ghosts or spirits in the tunnel. Once the tunnel was named the Henry E. Kinney Tunnel, the haunting began. There have been sightings of a man in a brown suit with a newspaper in his left hand standing at the northeast edge, looking into the tunnel. Some have said that they watched this man step in front of oncoming traffic and cause accidents at the mouth of the tunnel.

SEFGR conducted research based on these reports and did find an unusual EMF in the area of the reports. We also took pictures of the site and found an unusual apparition of the man described—a soft outline of a man with what looks like a newspaper in his hand. The energy in the area read about .6 to .7 mill gauss. The man appears to be looking directly at us in the photographs, but we were unaware of his presence. It wasn't until later examination of the digital photos, enlarging the area and sometimes putting the image in negative form, that we were able to see the outline of the spirit.

The second reported spirit was inside the tunnel. People who would walk through the tunnel at night would report seeing a Native American at the eastern side of the tunnel. He always wore very long, brightly colored patchwork shirts, belted at the waist, and a hat that looked like a turban with a feather stuck in the front. Witnesses claim that he would jump over the railing of the tunnel and run straight to and through the center wall.

In this case, our findings were similar to those concerning the man in the brown suit. As we walked through the tunnel, we took pictures every couple of feet. Upon reviewing the pictures, we found a slight shadow of this figure as well. The figure seems to be looking at the railing with one arm bent, as though it were ready to grab the rail.

Orbs appeared along the walkway and on the ceiling of the tunnel. We weren't able to conduct EVP investigations due to the noise level—traffic going through the tunnel made this impossible. Since beginning Fort Lauderdale Ghost Tour in 2004, we have yet to have any other reports of these phenomena.

FORT LAUDERDALE MUSEUM OF ART

It was the year 2005, my second year of running Fort Lauderdale Ghost Tour, and the Fort Lauderdale Museum of Art contacted me to hold a special event for their employees and volunteers. They had just completed the Princess Diana exhibit, which was a great success for them. They wanted to show their appreciation to their employees for a job well done with a dinner and nighttime stroll with the ghosts of Fort Lauderdale. I agreed, and a date was set.

I arrived early, as usual, to greet those interested in taking the ghost tour. It was drizzling rain, and like most rain in Fort Lauderdale, it didn't last long. We were a large group and we huddled in a hallway right outside the Cheesecake Factory, waiting for the last-minute arrivals to appear. People were anxious and they began to talk amongst themselves. I kept hearing whispered voices saying, "Should we tell him about our ghost?" Naturally, my curiosity got the best of me and I said, "OK, I hear you have a ghost in the museum. Come on, spit it out."

The leader of the group explained their story. A couple of years earlier, an office staff member had died on the premises. Since then, his spirit has been wandering the upper floor of the museum. He was a dedicated worker who hardly missed a day of work, and so is his spirit. From security staff to the docents, they all had stories to tell me.

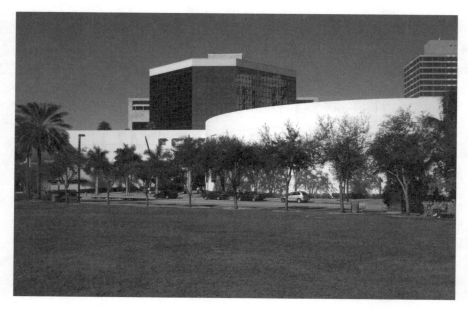

A view of the Fort Lauderdale Museum of Art on Las Olas, taken from the park.

One person said she had known the man well, and when she walked the hallway, she often heard footsteps following her from behind—the heavy steps of a man's leather-soled shoes coming from inches away. Those who knew him better would hear their names being called from down the hallway, only to find that there was no one there. Others experienced a physical haunt—a pat on the shoulder or a brush of the hair. Those who stayed late sometimes heard the rattling of doorknobs.

I asked them how they knew all of this was the work of one ghost. "The smell!" they exclaimed. The man had apparently loved to smoke cigars, and knowing how offensive some people found them to be, he would come back from his break and go directly to his locker, where he would douse himself with cheap aftershave. In his afterlife, the smell became his calling card. The mixture of cheap aftershave and cigars would linger in the air following these phenomena.

I had at least seventeen people tell me about the museum's ghost, and there were only about thirty people in the group. For newcomers, dealing with a resident ghost was a lot to get used to. For those who had known the man in life, the haunting was a reminder that he was always there, watching over them and wishing he could work another day at Fort Lauderdale Museum of Art.

Fort Lauderdale Museum of Art

The Fort Lauderdale Museum of Art was opened in 1958 at 625 Las Olas Boulevard. In 1986, the museum moved east on Las Olas to its present-day home. In March 2001, the museum expanded its collection and revived its overall appearance. Personally, I love to see its exhibits, and I have learned a lot walking through its halls. From Princess Di and King Tut to the works of the masters, this is the place to go to feed your love of art and beauty.

RAILROAD TRACKS
AT THE RIVERFRONT

The Florida East Coast Railway reached Fort Lauderdale in 1896, thanks to Henry Flagler. He hired Philemon Nathaniel Bryan as the purchasing agent responsible for the four-hundred-man crew laying down the tracks from Pompano Beach to Miami. P.N. Bryan had help from his two sons, Thomas and Reed. Along the way, Bryan purchased land for himself and his sons, and thus was born the neighborhood we call Downtown Fort Lauderdale.

A drawbridge was built on April 22, 1895, where the railroad met the New River. It was opened by a system of horse-powered cables and pulleys. At nightfall, the bridge would remain down and nothing larger than a small boat was able to pass through. At dawn, the horses were put in place and the bridge was again active and ready to let the first boat pass. In 1913, right after the great fire of Fort Lauderdale, the bridge was replaced with a lift bridge design that used water to raise the bridge. For the bridge to fall, pumping stations located at the eastern side of the bridge would pump out water from large containers to counterweight the bridge. To raise the bridge, the water was pumped back into the counterweight containers.

This has always been a dangerous site. In the years before electric guardrails, there was no barrier to prevent people from crossing the tracks

A steam train on an
FEC track in Fort
Lauderdale, circa 1960s.
*Photo by Florida Memory
Project.*

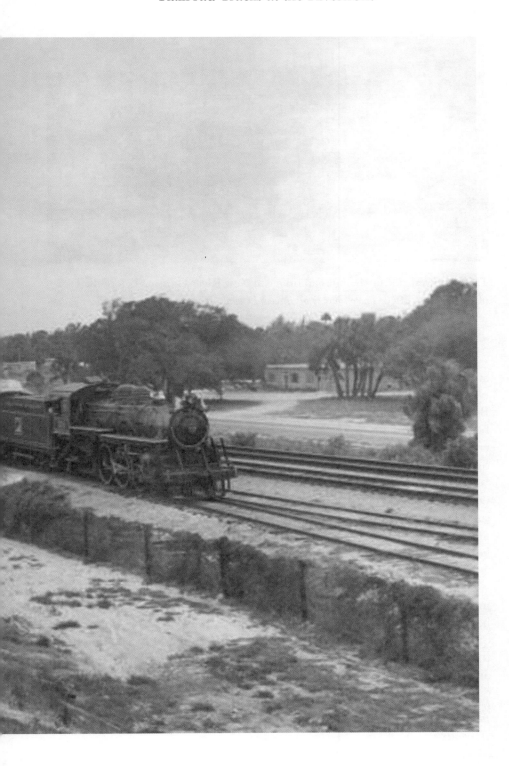

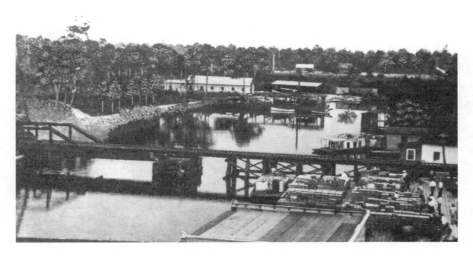

The southwest side of the railroad bridge at New River Crossing before the fire of 1912, circa 1910. *Photo courtesy of Broward County Historical Commission, from Judge Robert Scott Collection.*

at the riverfront. An alarm was set to go off when the bridge fell, alerting boaters that the bridge was going down. In addition, there was the wild Bourbon Street atmosphere that had been established when Al Capone became a resident in the 1920s. Even now alarms, guardrails, traffic crossings and live guards still cannot prevent the loss of lives on this little quarter mile of tracks.

Within the past eight years, fourteen people have died at the lift bridge where the street crosses the railroad tracks. Of the fourteen deaths, suicides are the most common. The other deaths are due to the stupidity and lack of common sense that accompanies drinking too much. It has gotten so bad that the railroad put in a security post—when the bridge goes down, guards patrol the pathway and the tracks.

The most recent death occurred on a Thanksgiving weekend. A nineteen-year-old boy lost his life after drinking a bottle of liquor that he had taken from the Southwest Second Street bar where he worked as a bar back. As the train passed, he told his friends that he was going to be the first one to make it across the tracks. He ducked under the guardrail and waited for the caboose to pass. He made a mad dash across, but he didn't see the oncoming train on the opposite side of the tracks. He was killed and his body was dragged about three hundred feet from where the initial contact was made.

Others try to cross when the train is going really slow. They seem to believe that the connection between the cars is an easy way to get through the 120-car train while it is still moving. They trip or get caught on the hookups between the cars, falling to their deaths under the unforgiving wheels of the train. It is a gruesome way to die.

Reports of paranormal activity in this small stretch of property have been ongoing since I began conducting my tours. There have been reports of black shadows lying on the tracks, orbs or balls of light floating over the tracks and the occasional apparition in a digital photograph. Emails from people who have taken my tour include strange stories of what they have experienced along this deadly strip of tracks.

One guard, in particular, told some of the strangest stories. She would have to stay in the guard booth when the bridge went down. If she kept the door closed, she would sometimes hear a slap on the glass. Occasionally a handprint would appear, but it would slowly fade, like moisture on heated glass. It would scare the guard so much that she would leave the door open, so there would be nothing there for the entity to slap.

Another occurrence was the appearance of people lying on the tracks, waiting for the train to run them over. When one observer approached

The architectural relic of the bank entrance at River Front Crossing.

the black shadows, they would disappear in front of her eyes. This occurred so many times that she began to pick up big rocks alongside the track and throw them at the black masses. If the rocks bounced off, she knew they were real people; if the rocks passed through, she knew they were spirits.

When the sun sets along the tracks, it is the best time to catch a glimpse of the "shadow people." From balls of darkness to faint shadows of men or women, these apparitions occasionally appeared during our twilight tours on Sundays, which we no longer offer. I encourage you to wander down to the tracks at dusk and pay a visit to the shadow people.

THE NEW RIVER INN

Philemon Nathaniel Bryan (1844–1925) was the ex-mayor of New Smyrna and was commissioned by Henry Flagler to be in charge of the Florida East Coast Railway running from Pompano Beach to Miami. Bryan moved down to Fort Lauderdale after the devastating orange freeze in 1895. He thought this move would provide the perfect setting for his new orange groves and the start of a new life for him, his wife Lucy Catherine Bryan (1852–1924) and their seven children. Knowing that the railroad was coming through Fort Lauderdale, he started to purchase hundreds of acres east and west of the railroad. One site became Fort Lauderdale's first railroad depot and the root of the city as we know it today.

P.N. Bryan's two sons were in charge of most of the operations on the property and the orange grove to the west of the depot. Reed and Thomas Bryan were also responsible for the four hundred laborers who laid down the track for the coastal railway. The New River Inn was the site of planning for the development of Fort Lauderdale. This area was considered the first neighborhood of Fort Lauderdale, and many developers, homesteaders and politicians came to check out the budding city. On February 22, 1896, the first steam engine pulled into the New River Station. In April 1896, the railroad reached Miami. If anyone had to go farther than Miami, they had to travel by stagecoach.

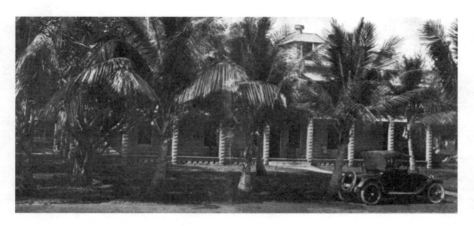

The New River Inn, circa 1917. *Photo by Florida Memory Project.*

Nestled along the New River, just west of the railroad tracks, the New River Inn, which is now the Old Fort Lauderdale Museum of History, stands as Fort Lauderdale's first and oldest inn. It was the first building to be listed on the National Register of Historic sites in Broward County. Construction began in 1896, and was completed in 1905. Napoleon Bonaparte Broward, the governor of Florida, stayed overnight at the opening of the inn. This old hotel, now a museum, has twenty rooms and only two bathrooms. That was considered a luxury in 1908, when most people still had outhouses. It was one of the first buildings to use carbide lighting. Built by Edwin T. King for Philemon Nathaniel Bryan, under the watchful eye of his son Thomas Murray Bryan, this building was constructed with sand dredged from the shoreline. Each hollowed concrete block was made only yards away from the construction site. All the wood is Dade County pine, like most of the buildings by E.T. King.

P.N. Bryan was in his sixties when the inn was completed, and he died at the age of eighty-five. His wife died one year earlier. The inn went through many changes and became a motel in the 1950s and '60s. It became a run-down, decrepit site until the city finally took over the property, fixed it up and placed it under the care of the Fort Lauderdale Historical Society. It is now a part of what we know as "Old Fort Lauderdale Village," which houses several buildings of historical interest.

There are several ghosts haunting the property. I get all types of reports from workers who work in the museum, patrons who visit and even passersby who walk past the museum only to be stunned by the

vision of a ghost. SEFGR has never conducted an investigation at the New River Inn, so we could not gather information to support these claims.

One spirit is called the "Matrix Man" by the teenagers who hang around the property in the hopes of glimpsing one of the New River Inn ghosts. He is so called because of the long, black trench coat he is rumored to wear. I am inclined to believe that this might be one of the many railroad men who used to stay at the inn as they passed through town. The Matrix Man appears at the front door and paces under the veranda to the edge of the building near the fire escape. He does this about two or three times and then stops between the second and third pillars, looks up with an angry face and vanishes.

We believe that one spirit belongs to P.N. Bryan. Many passersby report looking through the front door into the lobby of the old inn, only to be greeted by the face of an old man with a beard staring back at them. Those who have taken pictures of the front door at night often are stunned by the photographs, which clearly show the palm of a man's hand in the window of the front door. The image is reminiscent of the way celebrities hold up their hands to block the paparazzi. The hand is attached to an arm in a yellowish shirt, but nothing else is visible.

The next spirit is a young girl, about eight years old. She has curly blonde hair and wears a white lace dress with little black boots. She has been seen on the second-floor veranda of the New River Inn and on Southwest Second Street. She has also been spotted walking along the riverbank playing with an old-fashioned toy, a spoke wheel and stick. She is so lifelike that people will sometimes ask her if she is part of the museum, maybe as a period actress. She looks down from the second-floor veranda and says, "I live in a two-story house," and then she disappears. She also likes to play hide-and-seek with the children walking along the pathway beside the New River.

Who is this girl? Did she die on the train tracks? Did she drown in the New River? There is much speculation about this young specter. When people visit the replica schoolhouse in the Old Fort Lauderdale Village, they claim that the spirit belongs to a young girl in a picture of Miss Ivy Cromartie's first class in 1899. That young girl is listed as LuLu Marshal, but little is known about her life or where and when she died. Since she communicates with people walking along the river, we know that she is an intelligent haunt. Some people claim to see her as far as Southwest Eleventh Street, so we don't believe she is grounded to a particular area.

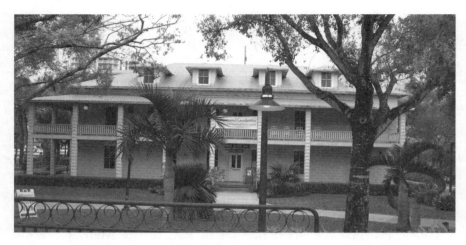

The New River Inn is now the Fort Lauderdale Museum of History.

Please visit the New River Inn. It is an active museum and teaches the history of Fort Lauderdale. From the natives who first called this area home to the movies filmed here today, the museum is a great place to spend an afternoon and find out that Fort Lauderdale has more to offer than spring break.

THE KING CROMARTIE HOUSE

In 1899, Ivy Julia Stranahan was the schoolteacher at the first school in Fort Lauderdale. She was brought here to teach by Broward's first contractor, Edwin T. King. Mr. King followed Philemon Bryan down from New Smyrna, Florida, in 1896, traveling on the new railroad that Mr. Bryan and his sons helped to create with the guidance and money of Henry Flagler. E.T. King had a family that needed to be taught and he wanted the new town to have a school. His daughter, Louise King, was a teenager at the time. She was a lovely girl, but she needed to complete her schooling. It took two years and several rejections, due to the lack of students, to get the then-young Miss Ivy Julia Cromartie to agree to teach here in Fort Lauderdale. Only after the town had nine school-age children were they given a teacher.

After the first schoolhouse was built in 1899, Ivy sometimes encouraged her family members, who had already established themselves here in Fort Lauderdale, to visit her there. Her brother, Bloxham Alva Cromartie, was a merchant in town and worked only walking distance away from the school. Being the first colonists, as they called themselves, the Cromarties and Kings would hold many social events together. Bloxham Cromartie and Louise King grew fond of each other, and one day Bloxham asked E.T. King for his daughter's hand in marriage. It took a while before he

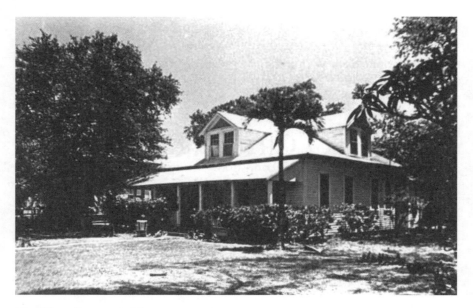

The King Cromartie House at its original site, where Smoker Park is now located. *Photo by Florida Memory Project.*

granted that wish, but the couple was finally married. E.T. King built them a house in the Rio Vista community, which was right across from the Stranahan Trading Post. This house was completed in 1907 and was a small bungalow made of Dade County pine. It was a fine wedding gift to the young couple when they were married in the year 1909.

The house stayed with the King family all the way up to 1968, not long after the death of Louise King Cromartie. In 1971, the house was moved to where it stands today, at the site of the old playground for the children of Fort Lauderdale's first school. It was moved because it was scheduled to be demolished by the new owners of the property and the Junior League of Fort Lauderdale saved it. They moved it by barge via the New River. In 1994, the historical society assumed custody of the property and made it into a museum, where people can learn how pioneers lived in the early 1900s.

In 2000, architects used the house as a headquarters for planning renovations to a new building acquired in 1978 by the historical society. The building was the old postal annex. They worked long hours drawing plans to restore the building to its 1949 splendor. It now houses the historical society's research department.

Two of the architects working in the house in 2000 had a habit of staying late. The historical society would send someone over to tell them that they would have to quit for the evening. One night, after wrapping up their work and helping the historical society member check the house to make sure there was nobody left inside, they turned on the alarms and locked up. The three made their way to the parking lot at the side of the building. As they were each putting their keys in the ignitions, they looked up to see something that caught them off guard.

The lace curtains in the second-floor window moved to the side, as though someone were watching them. On closer inspection, they saw a woman standing behind the open curtain. She wore a pink dress with a high collar and lace sleeves. Her hair was strawberry blonde, with curls that came down the sides of her face. The rest of her hair was pulled back in a bun. She stared down at them for at least ten seconds and then gently let go of the curtains and backed away from the window.

They had checked to make sure there was no one inside. They had set the alarms. And yet, all three of them saw the woman. If they hadn't believed in ghosts before, they certainly did now. The architects returned to work the following day shaken and jittery.

That isn't the only story I've heard about the house. Many passersby in this vibrant neighborhood have witnessed the curtains opening and

The bedroom window from the north side of the house.

King Cromartie House at its new location on Southwest Second Avenue.

closing. There were many times when someone on my tour would point and exclaim, "There is someone inside the house." Sometimes I would look around to see a curtain gently close in the darkened house.

The phenomenon of the curtains is sometimes explained away by the air conditioning turning on and off. Some say it's the wind, but the windows are painted shut and there is no chance of the slightest breeze coming through from outside.

The only deaths reported in the house were Louise King Cromartie and Bloxham Cromartie. Bloxham died first, and decades later his bride followed. We believe the "pink lady" is Louise, since her hairstyle rarely changed. In many pictures she wore her long locks in a bun, with strands of curls hanging down the sides of her face.

I have also witnessed the front porch swing rocking back and forth, with no wind to justify its movement. It often startles people on my tour to see a swing go from a still position to a full rock. Another phenomenon is the sound of children at play. The house was placed at the site of an old playground. The sounds of children squealing, chatting, singing and chasing each other have been reported to the groundskeeper. The commotion is always followed by abrupt and complete silence—quite unsettling for those not used to it!

The King Cromartie House is open to those who tour the Old Fort Lauderdale Museum, also known as the New River Inn, for a slight fee. All the furnishings are from the pioneer period, so you really get a feel for what it was like to live during that time.

THE RIVER HOUSE INN

The River House Inn restaurant is composed of two houses. The first house was built in 1897, and is known as the Camille Perry Bryan House. It was the home of Thomas Bryan (1878–1968?) and his wife Camille (1879–1981), who he married in 1904 and who lived to be 101 years old. They had only one child, a son named Perry (1908–1953). Thomas was one of the leaders in developing the neighborhood we now call Fort Lauderdale. He brought electricity to the city in 1912 by convincing General Electric to build the first generator for this budding town. He was the owner of the Fort Lauderdale Ice and Light Company. He was also the first electrical contractor. Thomas grew oranges for his father at his grove on over eight hundred acres of land. Thomas devoted ten acres to tomatoes and two acres to potatoes. He was responsible for the division of the town into the streets we have today. Thomas's home was built by Edwin T. King using concrete blocks made from dredged sand, and all the wood is Dade County pine.

The second house is the Reed Bryan House. It, too, was a gift from Philemon Bryan to his son in 1903, and it also was built by Edwin T. King. Reed's home has a wraparound veranda on the ground floor and the second level of the house. Thomas's home has a small veranda off

the second floor. All the verandas are now enclosed with glass windows to provide cozy eating places for the restaurant's diners.

These buildings were considered the beginning of the neighborhood we call Fort Lauderdale today. The Bryan brothers were instrumental in promoting westward growth. They were also in charge of the orange groves that their father started while these homes were under construction. The orange groves were planted in the area of the former fort once commanded by William Lauderdale. The orange groves are now gone and the property has been subdivided to create homes and streets for Cooley's Landing and Sailboat Bend.

The Bryans occupied these houses until the 1970s and then sold them to developers, who combined the two homes into one great restaurant. First known as the Bryan Homes, then the Chart House, then Reed's River House, it later became the present-day River House Inn.

When the buildings were converted into a restaurant, employees would often see and hear unusual happenings in the two structures. Everything was hush-hush until the opening of the River House Inn in 1999. Lights went on and off at will, music volumes turned up and down, and then off, pictures flew off walls and apparitions were sighted by patrons and employees alike. Never dangerous and always amusing—except to the workers who have to clean up and adjust lighting and music—the ghosts have free rein over this dwelling.

SEFGR has documented several interesting occurrences, including the pulling of hair in the Parlor Room on the first floor of Reed's side of the house, where the ghost of Barbara Estelle, the last living relative of the Bryan family, would appear from time to time. Patrons and employees would see her from the corners of their eyes, but when they turned to look at her straight on, she would vanish. Barbara has appeared on both sides of the restaurant, and only for seconds per appearance. She has been seen walking on the veranda, in the hallways and in the lounge across from the bar. During major holiday periods, she has been known to throw sugar packets into the hallways for staff members to gather, only to repeat the trick later.

During the Christmas holidays is when most of the mayhem begins. The restaurant is often decorated to the height of holiday spirit. Christmas trees, garland and strands of Christmas lights are all aglow. Most of the decorations that are inside the restaurant have to be turned off by hand before leaving the establishment. The manager and employees sometimes go to the local taverns just down the street after work. After merrymaking at these taverns, they head for home and often

notice the Christmas tree lights turned on. They turn off the security devices and then turn off the tree lights, only to find them back on when they come into work the next day.

On the second floor of the Thomas Bryan side, sounds of young children playing are often heard on the steps that lead from the bar area to the rooms above it. Patrons sometimes complain about the children, only to find out that no one is making the noise. Often, guests bring their children along, and these youngsters tend to wander the hallways. They play ball with newfound friends. The sounds of a ball bouncing on the floor and walls of the Thomas side of the restaurant can often be heard. When found by their parents, the children have stories of a new friend, who likes to play ball. But when the parent tries to locate the new friend, he or she cannot be found. Some say they play with a girl; some say they play with a boy. We believe that the boy is Perry Bryan, Camille and Thomas's son, who is a predominate ghost in the Thomas side of the restaurant. He likes to play tricks on the staff, especially anyone that is new.

During our investigation of the River House Inn, we made contact with the spirit of Perry. He would spin turned-off ceiling fans at will, and would only stop them when he was ready. He also told us that he

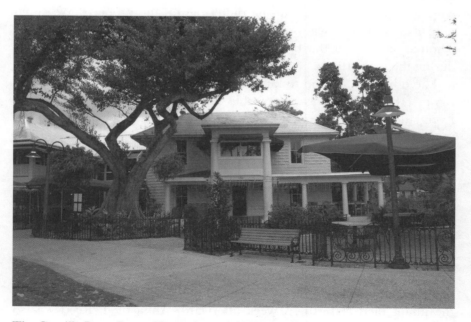

The Camille Perry Bryan House, home of Thomas Bryan, son of Philemon Bryan.

was a young boy of eleven. Perry was actually forty-five years old when he died. We found out that he had always been young at heart and that he and his friend Junnie (short for junior), son of Carl P. Weidling Sr., had been pranksters. Perry has played a couple of tricks on the office staff—mostly putting chairs in front of doorknobs in the empty office so the doors cannot be opened. Employees would actually have to break down the doors in order to gain access by popping the pins on the door's hinges. Perry also likes to drain batteries on cellphones or any type of portable devices, so workers know that they have to bring their chargers to work. During a séance, he claimed responsibility for most of the practical jokes in the restaurant.

In the bar lounge, there have been sightings of a man in a top hat who likes to sit in the corner of the room. He seems to be waiting for someone, but he always disappears at a second glance. Many a waiter or waitress has noticed him, and new workers often think he is waiting for a table or for the rest of his dining guests. When they walk by again, he is gone.

We made contact with this man using dousing rods. We use dousing rods for "yes," "no" or "maybe" answers from the spirits we find with high EMFs. The spirit in the bar lounge claimed to be the man in the top hat, but he said he was not a member of the Bryan family or an employee of the Bryans, and he didn't die on the property. We could only assume that he was one of the many contractors that stayed in the Thomas side when the building was converted into a boardinghouse during the early 1950s.

The other side of the restaurant was Reed Bryan's house. Reed Asa Bryan (1876–1937) was responsible for most of the draining of the Everglades to create the western part of town. He also helped his brother in the development of the railroad from Pompano Beach to Miami. He was contracted to do most of the dredging of the New River. The river would sometimes become shallow due to sand coming in from the ocean side of the river. It had to maintain twenty-foot edges and a thirty-five-foot center. This dredging was an ongoing venture, and Reed made most of his fortune on this project. In 1910, he became the first person in the city to own a car.

He married his wife Anna Baker Bryan and had two boys, Reed Bryan Jr. (1915–1976) and James Hawthorne Bryan (no dates of birth or death found). His wife became pregnant with their third child, and the infant died at birth. A week afterward, Anna died. Reed was so devastated by this loss that he packed a small hunting pack and went out

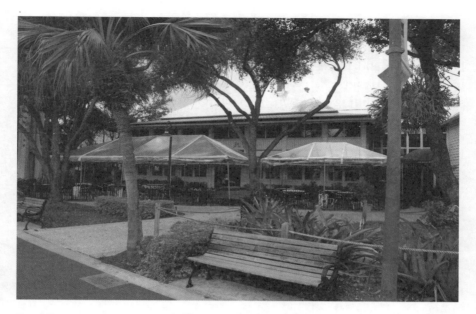

Reed Bryan's house. Reed was the older brother of Thomas Bryan and son of Philemon Bryan.

into the Everglades. He was gone for two months. When he returned, he had typhoid, probably from drinking contaminated water. After being nursed back to health, he met a beautiful teacher from Ohio. She was twelve years younger than Reed, and soon she became wife number two, Barbara Estelle Bryan (1888–1974).

On Reed's side, many patrons complain of a gray-haired man looking out the first-floor veranda windows. With arms crossed, he often scowls at diners as they eat their meals. When the guests complain to management staff or waiters, the man disappears. We tend to believe this is the spirit of Reed Bryan.

On March 30, 1974, Barbara Estelle passed away in her sleep at the age of eighty-six. The bedroom in which she died is haunted by her spirit. During an investigation, we held a séance in the bedroom. We recorded an EVP of who we assume is Barbara Estelle, saying, "Help me." She is often seen on the second-floor veranda by patrons on their way to the washroom. On one occasion, a mirror that hung in her bedroom flew off the wall and landed in the middle of the room.

There is a glassed-in porch that is off the side of the house, known as the piano room. It is the site for many entertaining nights of piano

The hallway on Reed Bryan's side, where the ghost of Barbara Estelle sometimes walks.

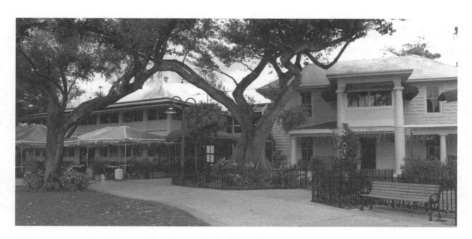

The full restaurant facing the New River. The two houses were combined to create one great, haunted River House Inn.

lounge singers and players alike. One night, one of the entertainers was frightened by one of the spirits—perhaps the ghost didn't like his musical talents. As the musician seated himself in front of the piano, the piano-key cover slammed before he could place his fingers on the keyboard. His microphone went flying across the room in one direction, his recording devices in the other and the vase filled with a beautiful flower arrangement slid off the edge of the piano and crashed to the floor. Quite shaken, he later composed himself enough to play for the rest of the night, keeping one eye on the piano cover just to be sure it didn't slam closed on his nimble fingers.

The River House Inn is a great place to dine—it has one of the best menus in town. Known for its Sunday brunch, it is a great place to sit under the veranda, sip a cocktail and watch the boats float by. If you are a resident, please check it out, and bring your out-of-town guests. If you are from out of town and want a chance to glimpse a ghost, the Thomas Bryan room is a great place for parties. On the Reed side, eat on the second floor in Barbara Estelle's room, or if you don't mind someone watching you eat your meal, take a seat at the third table from the end on the first-floor veranda.

COYOTE UGLY SALOON

Formerly known as the Rush Street Pub, this urban bar has been the site of ghosts and spirits for the last decade. When I first started Fort Lauderdale Ghost Tour, I would walk past it, never realizing the late night goings-on. It has always been a rowdy place, with the occasional overly intoxicated patron or a fight that would have to be broken up by the bouncers.

One night, as I was bringing my tour group past the Rush Street Pub, a man came out. He had a nice jacket on and a look of desperation on his face. He asked me, "Hey, you're the ghost guy?"

"I do the ghost tours here in Downtown Fort Lauderdale, if that's what you mean," I replied.

"Do you know anyone who does ghost busting then?" He looked around skittishly, as though he were afraid someone would hear him over the noise of the busy pub.

"Well, I do ghost investigations if that's what you're looking for," I told him.

He plunged his hand into his pocket and handed me a business card. "I've been having a problem with ghosts and I need some help. The girls [cocktail waitress] here are getting pinched in the rear and my bouncers are buckling over with pain to their stomachs over at

Coyote Ugly Saloon, where Fort Lauderdale's wild side dances on the bar and through which ghosts roam when closed.

this side of the bar." He pointed to the east side of the bar, which had its own exit. "When I bought this place, there was always talk about a gangster getting killed in my doorway and that they put his body in the New River."

I reached in my pocket and gave him a card with my ghost investigation group, SEFGR, information. "Call me," I said. "I'll see what I can do."

The following week, I walked past the pub, only to find it closed. I later found out that it had been sold and was going to reopen in a couple of months with some new and exciting plans. For the next few weeks, I would pass in front of the bar wondering about the problems that the last owner had faced and whether the new occupants would encounter the same troubles when they moved in.

Now the bar is called Coyote Ugly, after the famed bar in lower Manhattan. This bar utilizes the same formula of young girls dancing

on the bar in skimpy or provocative clothing. The bar is known for being the first bar on the strip to open early. The drinking starts early and continues until two o'clock in the morning.

The bar finally opened, and after a couple of months had passed, a young bouncer at Coyote Ugly heard me telling my tour group a story about the building across the street. He leaned into my group and said, "You know, our place is haunted too." I looked at him with a gleam in my eye and told him about the former owner and what he had shared with me. The bouncer said that they kept seeing an apparition near the back of the bar and that the manager, who is a woman, kept getting scared late at night—something to do with the door locks popping the keys out of the door when she tried to lock up. I told him that I would come back without my tour and have a talk with the manager.

I never got the chance to talk to the manager, but the same bouncer was working only a couple of weeks before Halloween 2007. I reminded him that we had met before. He introduced himself as Jeremy, the front bouncer. I asked if I could talk to the manager and he went back to find her. He came back and said that she was busy, but he told me more about the apparition.

Apparently, a mysterious lady dressed in Victorian clothing walks through a hallway in the back of the building. This Victorian woman doesn't seem to notice anyone, but seems focused on her mission. Dressed in a lace blouse and a dark gray or black dress, she walks as if she is in a hurry to get somewhere.

The bar was once a "Feed and Seed" store, which seems logical since it was located across the street from the old Stagecoach House, a large building that stabled horses on the ground floor. The second floor was where the stagecoach drivers would rest or sleep. Supposedly, it was the spot where people were able to catch a stagecoach to Miami, which was a five-hour trip, or maybe just around town, which by 1900 had only fifty-two residents, mostly farmers. Later on, Al Capone took over the Stagecoach House. He sent Machine Gun Jack McGurn to purchase the property and made it into his first speak-easy. Horse posts still line the street outside Coyote Ugly.

Jeremy told me that one evening, as the manager tallied up her deposit in the back, he took a couple of bar stools and made a bed out of them. Lining them in a row next to the bar, he pulled his baseball cap forward on his head and closed his eyes for a catnap. After only a few moments, someone grabbed his arm as though to

The corner main entrance into the Coyote Ugly Saloon.

say, "Hey, get up." Thinking it was the manager, he snapped, "I'm getting up! Geez, you're done early." As he fixed his hat, he looked around and found no one there. He said he couldn't get back to sleep after that. He waited for the manager to finish her paperwork and they left together.

The two sides of Coyote Ugly are separated by a wall. There are two doorways that lead into the main space—one in the front of the bar, and the other toward the back, where the hallway is narrow and dark. Each side has a hallway that goes to a back room. The east side

of the bar is where the manager's office is located. I rarely see anyone on that side of the busy bar. The west side of the bar is where the kitchen is.

The place is known for its body shots and its male clientele who come in to check out the young girls dancing on the bar. Coyote Ugly is a party place, but if you look toward the back of the bar and spot a lady dressed in Victorian clothes, or feel a pinch on your buttock or a jab from an unknown assailant, you just might be partying with more than you bargained for!

THE VOODOO LOUNGE

I have received many reports about this nightclub, but SEFGR has never conducted an investigation into these allegations. The Voodoo Lounge is in a building that was constructed in the 1920s and underwent a lot of renovations in the 1980s. Allegedly, it was once the site of a bordello. It has side alleyways where Johns were able to come and go with little notice. Considering that most of the men were probably married, the alleys provided perfect concealment for this petty crime. It was a microbrewery at one point in time and then it was turned into the Voodoo Lounge in 1998.

The Voodoo Lounge is a great dance-oriented club, where sounds of techno and electronic music bounce off the walls as people gyrate to these high-tech tribal beats. People dress to impress when coming to this upscale night club. Lights pulse and energy swirls as the dancers get on the floor and forget about their worries with newfound friends. Live entertainment is part of the excitement, with all types of singers and vocalists coming to belt out their latest hits. On Sundays, "Life Is a Drag" is the theme for a gay tea dance, which is popular with both straight and gay locals, as well as those who are visiting the Fort Lauderdale area. The nightclub has three different rooms, which offer different ambiances for varying moods. There is a main

The front entrance into the Voodoo Lounge facing the tracks of FEC Railroad.

dance floor and a bar area. "Envy" is the VIP room, which makes those who get to party there the "envy" of those who cannot get into the VIP area. It has a white-on-white interior design, with booths to carry on private conversations with friends and those who you want to know better.

As the club winds down and begins to close, the haunting begins. The ghost of a young boy has been seen running through the VIP section of the nightclub. Thinking that a young boy has wandered into the club, the workers will search frantically for the boy. After an extensive and fruitless search, they give up and lock the nightclub. This ghost made its appearance when the place first opened, but now he is rarely seen.

My research into this phenomenon has left me with more questions than answers. Who is this young boy? Did he die in the building? Why does he haunt the VIP room? Was he murdered or killed on the railroad tracks that lie in front of the nightclub? All these questions leave me baffled about this haunted nightclub.

Please visit this club and get your groove on in one of Downtown Fort Lauderdale's most upscale dance clubs. If you get a chance to be in the VIP room, you might want to keep a lookout for the young boy. No, they don't let children in, but this ghost doesn't seem to play by the rules.

THE PHILEMON BRYAN HOUSE

Philemon Nathaniel Bryan moved to Fort Lauderdale from New Smyrna after the orange freeze of 1895. The ex-mayor of New Smyrna wanted to make a new life for his family after the loss of his entire crop. Fort Lauderdale rarely drops below sixty-five degrees Fahrenheit, and he thought this would be the best place to restart his orange groves. He purchased 840 acres of land and planted twenty-five orange trees. With his wife Lucy Catherine Bryan and his seven children by his side, he thought he might have a chance at a new life.

Bryan was commissioned by his friend Henry Flagler (and financed by Nelson Aldrich Rockefeller) to help him finish his FEC railroad, which started in New York. The railroad was to run as far as Key West, Florida, but Philemon Bryan was only responsible for the track from Pompano Beach to Miami. He knew that with the help of his two sons he would be able to complete the task and make a pretty good-sized fortune to boot.

The train finally made it to New River in February 1896 and then to Miami by April 1896. Progress was fast in this pioneer town. Bryan, after seeing Flagler's success with the Whitehall, decided the hotel business would be his next venture. He broke ground as soon as he could to build the New River Railroad Station's first hotel. The hotel

had twenty rooms, two bathrooms and could accommodate forty guests. It was completed in 1905, but did not have its grand opening until January 22, 1908.

Poor Lucy finally got a house of her own in 1905 after the completion of her husband's hotel. Made from the same hollow bricks as the New River Inn, this house was fashioned in the classic revival-style of architecture that was popular during the time. The house was cozy and gave Lucy a private place of her own, away from the business that was just up the street. She loved to entertain and had many friends come and visit her at her home.

In 1924, Lucy was seventy-two years old. She was outside on her front porch shucking peas for the evening meal, when one of her friends pulled up in a car. She stood up and started to walk toward the edge of the steps and slipped on a pea pod and fell. She was carried inside and put in her bed on the second floor. She was in a lot of pain, but she didn't want to go to the hospital, thinking it wasn't too serious. Within days, she was dead, due to a broken pelvis.

The house is now the offices for the Historical Society of Fort Lauderdale and the American Institute of Architects, Fort Lauderdale chapter. Before it was acquired by the historical society and converted into offices, it was a boardinghouse for World War II spouses. Afterward it became a yoga center. Ladies would come to the house, change into their leotards and stretch to their hearts' content. It was at that time when a ghost was reported in the Philemon Bryan House.

I received several emails that seemed to have the same theme. A lady would go to the yoga center and get ready for her session of stretching. After changing into her workout clothes, she would go to the mirror in the dressing area. Making sure she looked presentable, she would examine her form, trying to see if anything was out of place. As she looked up from her reflection, she would notice a lady in a blackish gray wool dress in the mirror. The lady was standing toward the back of the dressing area, looking at her, with her arms in front, hands clasped. She had beautiful white hair pulled up in a bun. Startled at finding someone watching her dress, the woman would turn around to confront the lady in gray. As she turned to look at the corner of the room, she would find no one standing there. She would then turn back to the mirror where she had first noticed this unusual lady, only to find the reflection gone as well.

The historical society claims it does not have a haunting, or a ghost, inside this historical house. The society has occupied the building for

The Philemon Bryan House

An eastern view of the Philemon Bryan House facing the FEC Railroad tracks.

many years but admits that it cannot be certain what goes on in the wee hours of the night. If there were a ghost in the house, it would most likely be Lucy Catherine Bryan, and the historical society is confident that she would be happy with the way her house on Southwest Second Avenue is being maintained.

FIRE STATION #3

In 1912, Thomas Bryan contacted General Electric and convinced the company to install a generator to run electricity to the fine young city of Fort Lauderdale. The town of Fort Lauderdale had just been incorporated and a decision had been made to acquire the equipment for a fire station. The first fire chief was C.E. Newland, who was never paid for his services. In 1917, Milo Sherman became the first paid fire chief, earning a meager twenty-five dollars a month. All service before that year was on a voluntary basis.

The first extinguisher was pulled to the fire by a dozen or so volunteers. The first firetruck was a one-cylinder International Harvester truck. The pump hose was only five hundred feet long. Small fires were extinguished without the use of the pump. Some larger fires couldn't be extinguished because the hose couldn't reach a water source or, worse yet, the road conditions were too poor for the truck to travel over.

In 1912, the Wheeler Store caught fire and the wind blew sparks that ignited most of Downtown Fort Lauderdale. Since there were no fire alarms installed, there was no way to alert the town of 250 people. It was a wakeup call to the city of Fort Lauderdale to have a permanent fire station. The first fire station was located on Southwest Second Street and Andrews Avenue.

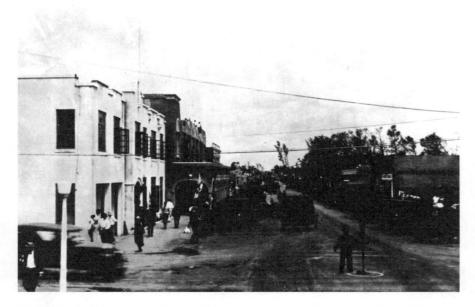

The white building is Fire Station #1, on the corner of Southwest Second Street and Andrews Avenue. *Photo courtesy of Broward County Historical Commission, from the Barwick Collection.*

On July 12, 1913, a fire started at the Osceola Inn. The fire was allegedly caused by someone smoking and accidentally igniting a mattress. This fire was more controllable than the one at Wheeler Store and was extinguished with little damage to the surrounding area. Still, this event reinforced the need for fire stations to be built in different locations in Fort Lauderdale.

After the hurricane of 1926, the city decided to build Fire Station #3 in the Sailboat Bend area. An architect was hired—Francis Louis Abreu had a great flair for designing buildings in Fort Lauderdale. He displayed a blend of Mediterranean and Spanish influence in his architecture. He had moved to the area after graduating from Cornell University, as his parents lived here at the time. As a child, he had lived in New York and Cuba. His first clients were his parents and their friends, who needed winter homes in Fort Lauderdale. During the real estate boom, Abreu offered his help and expertise to many of Fort Lauderdale's projects. Frank Stranahan was the city commissioner at the time and helped in the west side fire station project. It was started in June 1927.

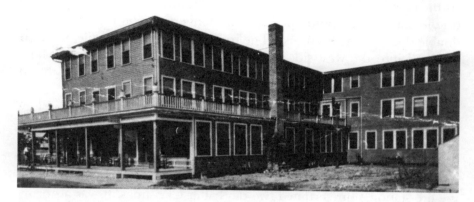

Osceola Hotel in its prime in 1912. *Photo courtesy of Broward County Historical Commission, from Diane Thompson collection.*

The Osceola Hotel fire was allegedly started by a mattress catching fire in 1913, burning the hotel to the ground. *Photo by Florida Memory Project.*

Fire Station #3 was an *L*-shaped, Spanish missionary–style building. At the center or bend of the *L* was a small tower where the front door of the station was positioned. At the longer end of the *L* were the double doors to the firetrucks. The roof was made of clay tile, in order to blend into the west side neighborhood of Fort Lauderdale. Many people would ride or walk right by the building, never knowing that it was a fire station.

In the winter of 1940, a young man volunteered to be part of Fire Station #3's crew. His name was Robert Leland Knight. He was the Golden Gloves champion and a very large, tall man. His uniform had to be specially ordered due to his size. His foot size was quite large, so boots had to be ordered for him as well. During his first week of working at the fire station, a fire erupted two days after Christmas. It was a stormy night, and everyone piled into the truck to go to the fire. Upon arriving at the scene, the rain made it difficult to see, and Knight jumped off the truck and landed in a puddle, into which a downed power line had fallen. He was electrocuted and died on December 27, 1940, at the young age of twenty-eight.

Ever since that tragic death, the firefighters of Fire Station #3 (now #8) have experienced a haunting. There are only a few individuals who have not had incidents with the ghost of Robert Knight. From doors opening and closing on their own, to footsteps walking around the berthing area (sleeping quarters), Knight has kept everyone on

Drawing of original sketches by Francis Louis Abreu of Fire Station #3. *Photo courtesy of the Fort Lauderdale Fire Museum.*

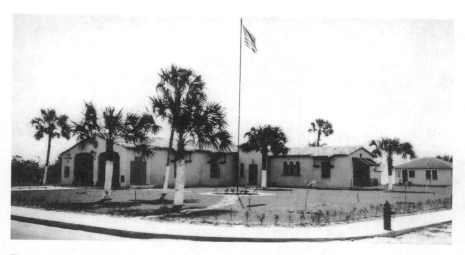

Photo of newly opened Fire Station #3 in 1927. *Photo courtesy of the Fort Lauderdale Fire Museum.*

their toes and at the edge of their seats. Hardly a week has gone by without a paranormal happening. This haunt has gotten a good deal of media coverage. Newspapers, magazines, Internet and even television were, and still are, interested in the ghost and haunting of Robert Knight.

Firefighters at Fire Station #3 have many stories to tell. One fireman claims to have seen a man with his hands cupped around his face in the bay windows of the firetrucks at two o'clock in the morning. He got up from his reports and went into the engine bay. He searched everywhere and found no one. Some say they are visited by Knight while trying to get some sleep. They report that when they are lying in bed, they feel the presence and warmth of a person sitting next to them. Others have reported feeling the blankets under their bodies moving, as though something were crawling in between the sheets. Upon inspection they find nothing there.

The television room seems to be one of Knight's favorite places. Many have taken pictures of orbs in this location. Knight is known to show up in the reflection of the television screen, but not in the room. While sitting in the television room, some notice the shadow of a person passing the doorway. The curious will get up, only to find there is no one in the hallway. Some say they see the shadow go into the room where the "dead man" used to sleep.

There are others who claim that Robert Knight made his presence known in different ways—cold breezes directed at the back of the neck and the sound of a disembodied voice in a room when there is no one there. Then there is their intercom system that would turn on by itself. Voices would come through the speakers when everyone was asleep in the fire station.

It was after my second investigation of the Stranahan House on November 12, 2005, that a group of us went to pay Robert Knight a visit. The group consisted of the paranormal research group Portal, headed by Chris Rodriguez; Miami Ghosts, headed by Marlene Pardo; and my group, SEFGR. We came with our equipment, which was still hot from the investigation at the Stranahan House, and with our clairvoyant, Mark Lewis. We went inside the fire station and heard footsteps, then noticed there were about six to eight televisions piled in the hallway of the front entrance. The building was empty because the firefighters had moved to a brand-new station. We turned around because we thought it might be a crime scene, the site where burglars were stashing their loot. We continued our research around the outside of the building.

Contact with Knight was brief, and we learned that he was looking for a person whose initials were "C.R." We did have EMF readings that ranged from the low .2 mill gauss to as high as .7 mill gauss. The energy was moving, indicating paranormal activity. Knight's sense of duty to the fire station keeps him there, even though he only worked there for two weeks before his death. The spirit of Robert Leland Knight is there because he feels he needs to be there. There was even speculation that he might not have been accidently killed. Being the Golden Gloves champ, horseplay might have been his undoing. Was Robert pushed out of the firetruck into the electrified puddle of water? To whom do the initials "C.R" belong? And why is Knight so insistent on finding "C.R"?

We made contact with some other spirits that evening at Fire Station #3. One was a young man who claims to have been killed in the driveway at the side of the building, where he was left to die in a pool of his own blood. He communicated with Mark Lewis, mentioning how sorry he was to have left his family behind when he was murdered in a drug deal gone wrong.

The neighborhood of Sailboat Bend was once a rough area, but it is now being revived as one of Fort Lauderdale's up-and-coming neighborhoods. Just across the street from the station was the hanging tree. Vigilantes would use that tree for their lynchings. Violence in the area was quite common as far back as the early 1900s. We have

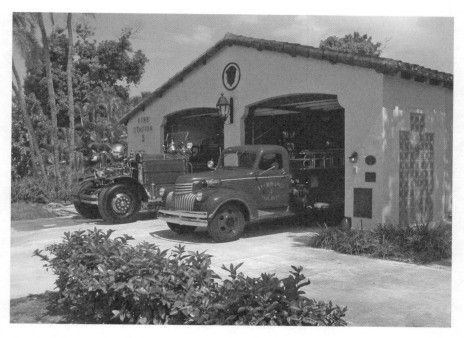

An official museum photo of the Fort Lauderdale Fire Museum. *Photo courtesy of the Fort Lauderdale Fire Museum.*

investigated a residential home in the neighborhood and it, too, was linked to a hanging. The second fort in the area was located only a short distance away from the fire station, so we do get the occasional Native American spirit who crossed paths with the infantry in the war of 1836.

All the firefighters have moved into their new fire station, and Fire Station #3 is now being converted into a museum. They are still working on the project to make it a place for children to come and discover what it was like to be a firefighter in the early 1900s. Renovations are still being done to the fine building that Francis Louis Abreu and Frank Stranahan created.

Please visit Fire Station #3 when it opens in late 2008. It will be a museum called the Fort Lauderdale Fire Museum.

The Dorms at the Art Institute of Fort Lauderdale

The campus is on Seventeenth Street West, near the causeway bridge. The white bus picks up the students and brings them up Federal Highway to Sunrise Boulevard, where the two streets become one in a bend to the east. Then Federal Highway veers north away from Sunrise Boulevard and becomes Federal Highway again. It is at this bend where the dorms of the art institute are located. The bus pulls up next to the larger dorms on the western side of the street. Across that busy street is the other, smaller half of the dorms, Sunrise Hall East.

In the 1920s, when most of the residents used the Middle River to get around town, a boardinghouse was located where Sunrise Hall East now stands. People who were looking for a more permanent residence used to stay there as they got situated in the surrounding Fort Lauderdale. Around the early part of the 1930s, the three-story wooden structure became a house of ill repute. Prostitutes were steady patrons to the rooms, which were rented out by the hour. The police would raid the motel for drugs and prostitution on a regular basis, and the occasional murder or suicide darkened its walls. In the 1960s the building burned to the ground. The rumors that residents in the community burned it down were never backed by the police, but who would arrest someone for putting an end to most of the crime in the area with a single strike

of a match? There were even rumors that people died in the fire, but I have found no evidence to support those claims.

The area stood as a vacant lot until the 1970s, when someone had the great idea to put a hotel there. This time a pool was built on the premises, but the hotel never became successful and it went out of business. Maybe it was the position of the building, which was long and narrow and had windows facing the businesses to the north and south of the structure, or maybe the rumors that the place was haunted had something to do with its failure.

Friends who used to stay in the art institute dorms would talk of restless sleep and hearing eerie noises in the night. When I worked in retail, some of my employees told wild stories about friends who had problems with the ghosts that dwelled in Sunrise Hall East.

One young man used to complain that his closet door would open during the night. He came back from class one day and found all of his clothes pulled out of the closet and lying on the floor. Those who knew about the haunting, especially the Goth kids, would hold séances and use Ouija boards to contact the dead. There were tales of Tarot readings interrupted by cards flying off tables and lights being turned out, leaving students stunned and frightened. Most needed a change of environment and banded together to find apartments off campus.

There are some haunts at Sunrise Hall East that we consider to be residual, meaning they occur on a regular basis and happen at certain times in the evening. Unlike an intelligent haunt, in which there could be communication with the entity, these residual haunts are sounds— like the *click-clack* of high-heeled shoes on the walkways to the rooms. Sometimes the footsteps stop in front of certain doors and the doorknobs turn, and then nothing else happens.

Another frequent sound is the clanking of something heavy hitting the roof over a part of the dorms. Sounds of footsteps on the roof are common as well.

The most common sound, and also the most unnerving, is the shrill sound of a woman's scream. Many times police and the dorm monitors have been called to Sunrise Hall East by students who aren't used to hearing this terrifying sound in the middle of the night. Whimpering, moaning and crying have also been heard, usually around and after midnight. Most of the sounds come from the upper floors of the dorm, but all who have tried to find the source of these noises have been unsuccessful.

The front entrance into the dorms from the busy street of Federal Highway.

Shadows are some of the other phenomena that occur in Sunrise Hall East. The shadows pass by the windows of the dorms. Sometimes they stop, as though peeking into the room.

Are all these paranormal happenings echoes of things that happened in the past? Paranormal researchers have been denied entrance by the staff to conduct any form of investigation into these happenings. Although the school has quite a liberal attitude, they aren't interested in finding out what is scaring their students into moving out and finding alternative places to live. There are some students who find it cool to live in a haunted dorm—with the popularity of ghosts and spirits, they grin with delight as they tell their friends of the latest haunting of Sunrise Hall East.

You are not able to tour Sunrise Hall East. Visitors are not welcome in the dorms, unless you are a student with an ID card. I cannot give you the address to this site, but if you paid close attention to my directions in the beginning part of this chapter, they will lead you to this ghostly dorm. Better yet, become a student at the art institute and live in the dorms. Maybe you will have more stories to share with me!

THE EVERGREEN CEMETERY

The cemetery sign reads:

Many Civil War veterans are buried at Evergreen Cemetery in addition to the founding families of Fort Lauderdale including the Stranahans [who built Stranahan House on Southeast Sixth Avenue], *Bryans, Kings, Cromarties,* [the maiden name of Ivy Julia Stranahan (1881–1971)] *and the Olivers. This burial place for the early residents of Fort Lauderdale was established by Mr. and Mrs. E.T. King in 1910. In 1910 or 1911, a funeral director from Miami moved many bodies from the first burial ground. In the proximity of what currently is Southside Scholl on Andrews Ave, to the newly created Evergreen Cemetery in 1917, the City of Fort Lauderdale purchased the cemetery. In 1921, the American Legion purchased four lots set aside for the burial of veterans. Shortly thereafter, the Benevolent and Protective Order of Elks purchased lots 34 and 43 for the indigent burials. In 1926, hurricane victims were buried in unmarked graves in the north central portion of the cemetery. This area is also the baby section. In 1935, B'Nai Israel acquired blocks one and two for burials of those of the Jewish faith. Evergreen Cemetery is Fort Lauderdale's oldest intact cemetery.*

Due to the lack of documented historical information, this chapter falls into the category of myths or urban legends. While researching this haunt, I ran into a couple of major roadblocks, but I included it because woven in every urban legend is a little kernel of truth. I would like to let those who are reading this chapter make up their own minds.

E.T. King purchased the cemetery for the city to use as its official place of burial. The first location was a small plot, and by the end of the century it would have been full. So, King was commissioned to find a location for Fort Lauderdale's newest cemetery. The southern part of the property was close to a quarry that was running dry. The edge of the property had a steep cliff like a boundary to keep people out. I always find it ironic that fences never seem to be enough to keep people out of burial grounds—as they say, "People are always dying to get in there." The east, west and north sides of the property were occupied by houses, condos and apartments.

On September 18, 1926, at 8:00 a.m., a hurricane blew through the Miami and Fort Lauderdale region. Many people sought refuge at the Gesu Catholic Church. The destruction was so devastating that most of Fort Lauderdale had to be rebuilt. Newspapers provided a wide range of information about the natural disaster. There were reports of 162 dead,

A granite park bench in Evergreen Cemetery.

3,800 injured, 242 missing and 31,000 persons rendered homeless by the destruction of 7,200 homes in the Miami-Dade and Broward region.

The mayor of Fort Lauderdale was John W. Tidball and our governor was John W. Martin. After a couple of days, they were forced to burn many of the homes because there was not enough help to remove the debris. There could have been bodies in those homes that were burned to the ground. Official counts of the amount of nameless dead varied from as few as eight to over two hundred. Each newspaper in town had a different amount and the actual tally was never determined.

Here in Fort Lauderdale, there were reports that the dead were brought to the Evergreen Cemetery if they were white; if they were African American, they were brought to the Woodlawn Cemetery for burial. Segregation, although not strict, was a part of Fort Lauderdale's history. Newspapers never told of what really happened to the African Americans during this tragedy. It wasn't until the 1970s that segregation was completely abolished from the South Florida area. Being from Long Island, New York, I had a hard time hearing and learning about this uglier side of our great city of Fort Lauderdale.

I contacted the Evergreen Cemetery, and they really didn't know where the unknown bodies were placed. They only know that it could have been in a mass grave, since there was no particular row marked in their records. Nor did they have a number for the dead buried in the mass grave. Urban legend puts the number between fifteen and twenty-five people, although two newspapers (the *Fort Lauderdale Herald*

The Hollis Apartments after the hurricane of 1926. *Photo courtesy of Broward County Historical Commission, from the Mrs. Clyde Brown Collection.*

Here was what was left of the South Methodist Church by the morning of September 19, 1926. *Photo by Florida Memory Project.*

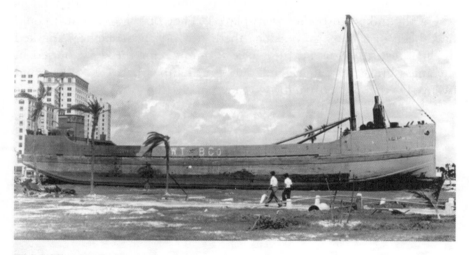

The *WT and B Co.* on dry land due to the massive winds and high tides from the storm. This ship was washed up in Miami. *Photo by Florida Memory Project.*

and the *Fort Lauderdale Daily News*) reported fifteen unknown dead. These unknown dead are supposed to be the cause of a haunting that occurs at the cemetery.

The people who live close by say they sometimes see mist rise and fall in the cemetery where it is presumed that the mass burial occurred. The fog rises straight up as though someone were rising from a grave. The fog moves about and then descends back down to the ground.

Sometimes people who claim to be ghost hunters come to the cemetery with cameras, hoisting their children to take pictures in areas not even

A beautiful statue of an angel adorns many of the graves and crypts of Evergreen Cemetery.

close to the area of the mass grave. They boast of taking pictures of white forms roaming around the cemetery grounds. Their claims may be true, but there have not been any scientific investigations conducted to support them. The cemetery closes at sundown and the city of Fort Lauderdale is not really interested in finding out whether it is haunted. There has always been "talk" of a lady in gray or white who haunts the area of the old mausoleum of H. Wayne Huizenga.

There is also a very amusing occurance that has plagued the cemetery, of which most of the Fort Lauderdale Police Department is aware. When a robbery occurs in or around the area of the Rio Vista Community, the robbers tend to go to the cemetery to hide out. Burglars who are on foot, for some unknown reason, think that the cemetery would be the last place the police would go to find them. It has been quite comical that the trail always leads to the Evergreen Cemetery.

THE RICHARDSON ESTATE

S ome islands are in tropical settings in the middle of the ocean. Some islands are in the middle of the Great Lakes. Just north of the Downtown area, there is an island in the middle of Fort Lauderdale. That island is called Wilton Manors. The original name for this island was *Colohatchee*.

Surrounded by a fork in the Middle River, the island was first used by the Tequesta Indians as a campground for hunting and fishing. They also buried their ancestors there. When the Spanish came, bringing disease and enslaving the Tequestas, this small island stood empty, except for the occasional Seminole who would canoe to its banks. It took until the early 1920s before plans were set in motion for Wilton Manors. When completed, it boasted 40 acres of waterfront and 345 acres of wooded-highland property, 15 miles of paved streets, 30 miles of cement sidewalks, 15 miles of white way lights, 30 miles of parkways, five city parks, a nine-hole golf course built by George Richardson Sr. at his estate and, of course, the Willingham estate.

On September 18, 1926, E.J. Willingham's dream was washed away when most of the new development was blown away in the hurricane. The tower still stood, but most of Willingham's estate was devastated. However, the hurricane didn't stop him from picking up the pieces and continuing the development of this fine town.

In 1954, George Richardson Sr. gave his property, 5.4 acres of land toward the south of the island, to Judge George Richardson Jr. Wilton Manors was off and racing to its future. The city had been incorporated in 1947. Willingham helped in the layout of this new, distinctive residential community. Streets were planned and a gateway into the budding development was constructed by Francis Louis Abreu. At the entrance of the island, Abreu built a Spanish-style fort tower.

The tower that once stood at the Five Points part of Wilton Manors was torn down due to misuse. It was occupied by a woman called the "Bird Lady." She had many birds living in the tower that weren't kept in cages. Vandals took over the smaller tower and ransacked it. The town thought it would be best to tear both towers down.

Wilton Manors continues to shine as one of the best neighborhoods in Fort Lauderdale. (I might be biased, however, since I live in Wilton Manors and love it!) Our community continues to give the best to its residents without losing the small-town touches.

As a ghost investigator and researcher, I was tickled to learn that we have a haunted landmark in Wilton Manors. It took me about a year to

Wilton Manors' tower gates at the north end of town. Francis Louis Abreu charged $50,000 to draw them up for Willingham's development project. *Photo courtesy of Broward County Historical Commission.*

finally get the opportunity to investigate the Richardson estate. When I first moved to Wilton Manors, the estate had fallen into ruin. Boarded up with hurricane shutters and fenced in, hardly anybody wanted to save it. Helen and George Richardson sold the estate and its nine-hole golf course to the city for $3.8 million in 2003. It was scheduled to be renovated and progress was slow. Stories and rumors of the contractors meeting up with ghostly disasters arose and many contractors refused to work at the location due to the ghosts.

One story was that a bulldozer turned on by itself and crashed into the pool next to the carriage house. Other stories were of contractors inside the manor house, visibly shaken after witnessing a shadow or ghost walking around the premises. Residents say they would see lights inside the structures, even when the estate was abandoned. The estate looks creepy, standing toward the back of the lot, closer to the river's edge than the street.

The construction site of a pool being filled in at Richardson estate.

It is said that when George Richardson Sr. died in 1954, a chauffeur, Buddy Hicks, who was working on the estate, was given his pink slip. He didn't take the news well, and he took the car out for his "last drive." The details are blurred, but Hicks got into an accident and died just as he was returning to the estate. His ghost or spirit has been rumored to be the cause of most of the paranormal happenings around the carriage house that was built in 1925. Both George Richardson Sr. and his wife Rachael died in the manor house. There is one other death on record of a man who was playing golf and was struck by lightning before the final closing of the golf course in 1959.

The renovations had not been completed when we first investigated this home in search of its ghostly residents. The roof was not yet fixed. The walls and floors were soaked with rainwater and the smell of mildew was everywhere. Our head equipment technician, William Elrod, or "Tiny," is an electrician and he deemed the house ungrounded. This means that if we were to keep the power on inside of the house, our EMF detectors would get false readings, since the electric waves would

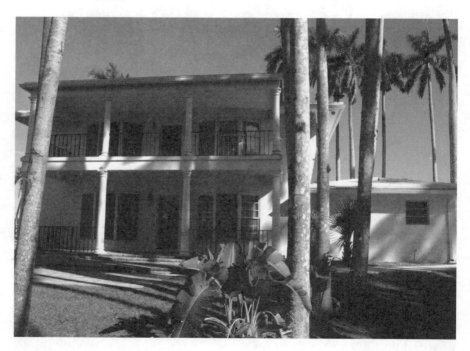

The front entrance to the Richardson's home, which faces east from the curve of Middle River's southern fork.

be literally bouncing off the walls of the manor house. We forged on, with help from the Paranormal Awareness Society, dividing up and splitting the large manor house into two sections.

We were greeted by Marlene Schotanus of the Stranahan House. She lives in Wilton Manors and knows many of the people in the Wilton Manors Historical Society. She was quite instrumental in getting us permission to investigate the property. I find her to be a great resource of information on the history of Fort Lauderdale and she always points me in the right direction to enrich my research.

After turning off the alarms and finding out the house was not grounded, we made the best of it with our handheld infrared video cameras and digital cameras. Heidi Ramirez (historical researcher for SEFGR) was responsible for laser thermometer readings. We roamed around the first floor, while on the second level of the manor house, the Paranormal Awareness Society took a chance at Judge George Richardson's master bedroom. The first level housed the children's rooms, the living room, dining room and small servants' quarters.

There was a small room into which I ventured alone. I don't recommend this to any investigator, as witnesses are crucial, but I had my video camera with me as my extra eyes and ears. The small room was under the stairs and looked like a storage area. As I went in, my camera kept going out of focus, like someone was cutting into my line of vision. The deeper I got to the back of the storage area under the steps, the more I had to fight back the urge to run. There was a blackness that my camera's infrared light could not penetrate. I slowly backed away from the deep corner and the camera started to work fine again. Then I heard a sigh in my right ear. I turned my head to the source of the sound and found the wall. I was stunned. I looked at my video camera only to find that the three-hour battery had lost almost all of its energy, and I had only been using it for twenty minutes. I headed back to get a new battery, feeling my way in the dark.

I then went to the side bedrooms belonging to George Sr.'s three children, George Jr., Kamie and Gex. As I went through the rooms, I left a digital recorder in each room to pick up EVPs. It was hard to walk around due to the fact that the floors had screens from the windows scattered across them. I tried to place the broken screens in the corners of the room so other crew members wouldn't stumble over them. The rooms were extremely hot. The windows were closed tight and there was no breeze. The rooms were lined up to the right with one long hallway leading to them. As I entered the second room, I became

ill to my stomach and felt dizzy. It may just have been the tight pattern of stripes and flowers on the wallpaper that plastered the room. I left the second digital recorder inside the room.

I went to the final room at the end of the hall. I guess it was George Jr.'s room as it was the largest room and he had been the eldest son. I powered up my digital recorder and began to speak out loud, asking if there were any spirits in the room and declaring that now would be the time to let us know that they were there. At that precise moment, Tiny came in from the hallway and said there was a cold spot coming toward the room. I felt the coldness hit the back of my neck, making the short hairs stand up. It felt good, in contrast to the stagnant hot temperature of the room. The cold spot went around the room and then it was gone. The room temperature was at eighty-four degrees and it dropped to seventy-five degrees in a matter of two seconds. It then went back up to eighty-four.

Later that evening, we went outside for a break from the heat of the house and to lay out a plan of what we were going to do when we switched sections of the house with the Paranormal Awareness Society. As I went outside, I took several pictures of the river across a lush tropical garden. The pictures I got were amazing—it was as though hundreds of orbs surrounded the area. I showed Tiny and he said he had captured the same phenomena on his camera. Marlene mentioned to us that an archaeological dig was done a long time ago and they found traces of a Native American burial ground. Human bone fragments were dug up and then placed back in their original spots. It became clear to me that this haunting was more than a disgruntled employee of Judge Richardson who was killed in a car accident. We were standing on graves of the Tequesta Indians. It was unusual to take a picture in one direction and capture hundreds of orbs and then turn in a different direction and find only a couple.

I started to wonder about the poor chauffeur, Buddy Hicks. I went to the carriage house, where the pool used to be that was now filled in. At a distance, I was able to take pictures of the landmark and found a single orb hovering on the second floor of the carriage house. This orb would move from one end of the house to the other, as though it were pacing back and forth. As I approached the steps to reach the second-floor landing, I was met by Paranormal Awareness Society members. They told me their batteries had gone dead, but when they replaced them, they still weren't able to take pictures, as if their cameras were locked. I tried to take a picture and the same thing happened to me.

The carriage house was locked. We had hoped to hold a séance there, but were only met with disappointment at not being able to get into the carriage house and our equipment failure. In some paranormal phenomena, batteries are drained due to the spirit needing energy to control or manifest a condition in an environment. We always carry extra batteries, but this was different—something was preventing both teams from taking pictures in one particular area. I logged the circumstance in my digital recorder and returned to the manor house.

The teams switched floors. We started to hear *booms* sounding outside of the house. We went onto the second-floor veranda, only to find fireworks igniting the skies. I took another picture of the carriage house. The orb was still there, guarding the second floor. We all went back inside and closed the door to the balcony.

I walked toward the back of the master bedroom where the bathroom and the multiple closets were located. I took pictures of the rooms, and then went back into the bedroom. I switched to my infrared video recorder and started to sweep video across the room. Tiny came in from the hallway and told me that the *booms* from the fireworks might disrupt our EVP work. At that very moment, the balcony door began to open. I told everybody to stand still and not to touch the door. As I was filming this, I started to take digital pictures with my free hand. I captured two orbs entering the room through the balcony door. Tiny continued to take more digital pictures and he captured the same two orbs beginning to circle us in the room. These orbs made it around us more than 360 degrees and then proceeded into the hallway and down the steps toward the first floor, where we lost sight of them. Everyone was stunned.

The paranormal community is at odds about orbs. Is it dust, insects or something paranormal? Orbs seem to accompany many different haunted environments. Some of the orbs I have encountered were pretty darn intelligent and stubborn. I say intelligent because if they were simply collections of dust, why would they fly upward? I know many would claim that wind is the cause, but these orbs seem to have an intelligence of their own. I've had orbs swirl around a stationary camera twice and then go back in the same direction they came from. Upon close inspection of multiple pictures of orbs, we have found no wings to lead us to believe they were insects. I have taken pictures of dust too—it usually has a gray or tan appearance. Some of the orbs we've encountered have color to them. They are perfectly round and usually have the appearance of a nucleus center, an inner wall and an

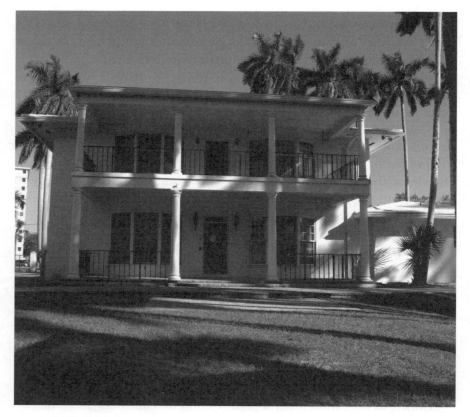

The Richardson's house.

outer wall. Just like a cell. Some people find shapes inside of orbs to resemble faces and other natural forms, which I discount. The eye likes to take random dots and shapes and try to make sense of them—this is called *pareidolia*.

It was getting late and the caretakers wanted to lock up the Richardson estate. I went back through the house to retrieve the recording devices that we had placed in different locations. I packed my EMF gauss meter and laser thermometer in their cases. The video and digital camera were then stored away in the camera cases. Then, we all went home to download the evidence we had collected in the four to five hours we were there.

We had successfully videotaped the doors opening on the second-floor balcony. The sigh in the closet was not picked up by my camera,

but we were able to get some pictures of both the orb at the carriage house and the orbs in the burial ground area. I think if we had had more time and could have entered the carriage house, we might have made contact with Rachael, or maybe Buddy Hicks.

The Richardson Historic Park is now open to visitors with many opportunities for the residents of Wilton Manors to take advantage of this great tribute to Judge George Richardson and his family. Kayaks and canoes are launched off the brand-new dock at the narrow, winding river's edge. Kayaks can be rented at the park for single and tandem use. Picnic benches sit beneath the massive trees that shade the house and much of the grounds. Take a walk along the nature trails and explore the area that the Tequesta natives used as a campground for hunting and fishing. Tours are available of the inside of the manor house, where you can take in the restored beauty. And you just might encounter a ghost inside, or out on the grounds, adding to your souvenirs of Wilton Manors' Richardson Historic Park.

The carriage house is believed to house the spirit of Buddy Hicks.

THE FAU MURDER

On January 12, 2006, the screams and pleas of a homeless man named Norris Gaynor didn't stop his attackers from beating him to death. Three homeless men were attacked that night by three teens with baseball bats and golf clubs who said they got the idea from playing a video game. By the end of the night, two of the three vagrants had survived, but the third had not, and the young teens became suspects for murder. The murder was captured by a surveillance camera in the outside lobby of one of Downtown Fort Lauderdale's popular college campuses, Florida Atlantic University. After attacking the three homeless men, the teens went to ditch their weapons and noticed one of the victims was sitting up and awake. They decided to beat Mr. Gaynor a second time, and left him to die.

CNN ran the video of the horrible attack on the homeless men, filling my head with sympathy pains at every strike. Florida Atlantic University was on my ghost tour route. There were always teens riding on skateboards or their BMX bikes, whizzing by my group as we walked along the streets of Fort Lauderdale. The quality of the video was not very good, but the teens looked vaguely familiar. I hated to think that anyone I knew, even peripherally, might have done this horrible act. If I did recognize one of the teens, would I remember a name? The days

Florida Atlantic University on Las Olas Boulevard was the scene of a murder that shocked America and exposed the horror of the homeless here in Fort Lauderdale.

afterward were filled with terrible searches through my memory and, worse, the replaying of the video of that poor man as he scrambled to get away from the beating and the torture.

The teens were found and the courts are still trying to determine their fates. The courts moved the trial to Miami because they felt it would be the right place for the jurors to make a decision. This event really shook Downtown Fort Lauderdale and all of its residents, including the homeless. The campus of FAU will never be the same.

FAU moved the bench on which the homeless man had been lying before the attack. It has also heightened its security. I'm sure the students of FAU look over their shoulders more often as they come out of the building and go to their cars in the back parking lot of the campus.

People always ask me, "Does a ghost have to be in an old building?" I tell them that it really doesn't matter how old the structure is. What matters are the memories that the spirit has and its attachment to a structure or a place.

One night, after a tour, I took a gauss meter to the FAU outside lobby. I checked to see if there was anything paranormal in the area where the homeless man had died. I noticed that there was an EMF and it was moving in a circular manner. I remembered the video of the murder—watching the man as he tried to get away, crawling around on his knees in a circle in an attempt to avoid the blows from the baseball bats. Could the murder have produced this energy? Was this a residual haunt or an intelligent haunt?

I took out my digital camera and captured an orb in the area of the outside lobby. Then I was approached by an FAU security guard and told I had to move off the premises. I didn't want to get arrested, so I complied. I could see it now in the *Sun Sentinel Newspaper*: "Ghost Tour Guy Gets Arrested at FAU—He Claims to See Dead People." It was not the kind of attention I wanted from the city of Fort Lauderdale.

A year after the murder, I was leading a ghost tour with a great group of people, some of whom were members of a paranormal group from up North. They had traveled a long distance to take my tour and learn about the haunts of Fort Lauderdale. I finished the tour and was taking everybody back to where we had begun, when we passed by the lobby of the FAU campus. I mentioned the murder and everyone remembered seeing the video on CNN and their local news. I told them about my findings in the area and the Northerners wanted to see if they could get the same results. They had their equipment with them and they started an EMF sweep of the lobby. The rest of the tour watched them conduct a mini-investigation.

The results were the same. They also found a magnetic field moving around in the lobby area. They took pictures and they, too, got an orb. In fact, they were able to get a couple more shots than I had before I was told to leave. They noticed that the orb was moving from left to right and then from right to left. It was moving in the same pattern as the energy field they were picking up from their gauss meters. The people on the tour were astonished to see an investigation happening in front of them. I was pleased to find that the investigators were finding the same results as I had, but I was saddened to think about this poor man reliving the last couple of minutes of his life, over and over again.

Another question I am often asked is: For how long does a haunting occur? I don't have a definitive answer for this question. I always respond, "Some last for just a short time, maybe until the spirit is finally able to rest in peace. Some last for centuries, as the haunts in Europe, like London or Rome. We could never know when a spirit or ghost will

The front entrance from Las Olas to FAU's campus. Mr. Norris Gaynor was sleeping on a park bench here when he was awakened by blows to his head from a baseball bat and golf club.

find its rest, but we do wish they would find it and move on from the pain or the longing of this earthly plane."

I hope Mr. Gaynor finds his peace one day and moves away from the pain and torture he was put through. The homeless here in Fort Lauderdale went underground. They used to be able to sleep with little worry, other than the police telling them to move on. Now they worry whether they will make it through the night without someone trying to hurt them. I always remember the words of my father when we came across someone less fortunate than us: "There before the grace of God goes I."

FAU campus is a great place for learning, and our community is a better place because of it. It is located one block east of the Fort Lauderdale Museum of Art.

GLOSSARY

disembodied voice
A ghost/spirit that is heard by human ears in a haunted environment.

electromagnetic field (EMF)
Static energy that is picked up by meters, usually measured by the gauss system of measurement. Most EMFs are stagnant and in electronic devices. When there is no source for the EMF, or if the EMF is moving, then it is called paranormal.

electronic voice phenomena (EVPs)
Voices picked up by an analog or digital recorder of a ghost/spirit that is present in a room but cannot be heard by human ears.

ghost
A term used to describe a spirit or specter. Some use the term to describe residual energy of a dead person that causes paranormal happenings to occur.

intelligent haunting/ghost

A ghost/spirit that communicates via EVPs, dousing rods, spirit boards or disembodied voices, knocks and noise. Questions are answered or comments are made in response to queries.

orbs

Round balls of light that appear in photographic evidence and in infrared video. Most orbs can be explained as dust. What we find to be paranormal is the orb that seems to have an intelligent pattern. They come in different colors and may be any size.

pareidolia

The process by which the human brain interprets essentially random patterns into recognizable images. Often, when we look at clouds in the sky, we put those random shapes together to form familiar objects. For example, "Doesn't that cloud look like an angel?"

poltergeist

The German word for "noisy ghost." This type of haunting is rare. Often, it can be explained as misdirected energy of a being in the environment that has repressed psychokinetic energy caused by mental trauma. A small percentage is spirits that are not happy about sharing their space. They will convey that unhappiness by making sounds, moving furniture or harming those in their paths. There is only a small percentage of poltergeists that can inflict harm—most just want to scare you away.

residual haunting

Also known as *post cognition* or *retro cognition*. This type of haunting produces the effect of going back in time, like a video that keeps playing over and over again. It is the reliving of an event in time that the spirit is unable to escape.

séance

Used to communicate with a spirit or ghost. Usually led by a ghost researcher or medium to obtain information about the spirit and why it haunts the environment. Most séances are held around a table or spirit board. Patrons hold hands to create energy that the spirit can use to make sounds, throw things or make something move in the room.

simulacra

From the root word meaning "similar." The mental habit that causes us to see such things is called pareidolia. For example, people often see the Virgin Mary in objects.

vortex

A portal or doorway through which entities enter or leave. These usually appear as spiral energy in photographs.

VISIT THE HAUNTS

Coyote Ugly Saloon
220 SW 2nd Street
Fort Lauderdale, FL 33301

Evergreen Cemetery
1300 SE 10th Avenue
Fort Lauderdale, FL 33316
954.527.0227

Fort Lauderdale Fire Museum
1022 W Las Olas Boulevard
Fort Lauderdale, FL 33312
http://www.fortlauderdalefiremuseum.com/index.php

Fort Lauderdale Museum of Art
1 E Las Olas Boulevard
Fort Lauderdale, FL 33301
954.525.5500

HENRY E. KINNEY TUNNEL
Federal Highway/Route 1 at Las Olas Boulevard
Fort Lauderdale, FL 33301

KING CROMARTIE HOUSE
229 SW 2nd Avenue
Fort Lauderdale, FL 33301

NEW RIVER INN
231 SW 2nd Avenue
Fort Lauderdale, FL 33301

PHILEMON BRYAN HOUSE
227 SW 2nd Avenue
Fort Lauderdale, FL 33301

RAILROAD CROSSING
SW 2nd Street and SW 2nd Avenue at Riverfront Walkway
Fort Lauderdale, FL 33301

RICHARDSON HISTORIC PARK AND NATURE PRESERVE
1937 Wilton Drive
Wilton Manors, FL 33305

RIVER HOUSE RESTAURANT
301 SW 3rd Avenue
Fort Lauderdale, FL 33312
954.525.7661

SMOKER PARK
500 S New River Drive
Fort Lauderdale, FL 33301

STRANAHAN HOUSE
335 SE 6th Avenue
Fort Lauderdale, FL 33301
954.524.4736

VOODOO LOUNGE
111 SW 2nd Street
Fort Lauderdale, FL 33301
954.522.0733

BIBLIOGRAPHY

Baily, John. "A Chronological History of Fort Lauderdale and Its Environs." http://www.johnbailey.net/FortLauderdale/Broward. htm.

Fort Lauderdale Herald, September 19, 1926.

Gillis, Susan. *Fort Lauderdale: The Venice of America*. Charleston, SC: Arcadia, 2004.

Heede, J.L. "Sam." "Our Bryan Pioneers." *Broward Legacy* 2 (Winter/ Spring).

Kersey, Harry A., Jr. *The Stranahans of Fort Lauderdale: A Pioneer Family of the New River*. Gainesville: University Press of Florida, 2003.

Kirk, Dr. Cooper. "William Cooley: Broward's Legend." *Broward Legacy* 1:1 (1976): 12–20.

Wallman, Brittany. "Phantom of the Firehouse." *Sun-Sentinel*, March 8, 2004.

ABOUT THE AUTHOR

John Marc Carr was born in Astoria, Queens, New York. At the age of three, John and his family moved to Long Island to escape the hard life of the city. They lived in a Cape Cod house in Garden City Park and began to remodel the house when Carr was eleven. As soon as the renovations started, unusual happenings began to occur. Doors would open and close on their own, footsteps could be heard walking up and down the steps and the sound of names being called would lure family members to empty rooms. John spent seven years hiding his head under his blankets and feeling unseen visitors sitting next to him on his bed. The family eventually had the house blessed and later moved away, but his experience with the paranormal shaped his life and forged his career.

John now uses his expertise as a paranormal investigator and helps those who are going through the same ordeal with their own homes. He founded SEFGR, the South East Florida Ghost Research team, and enjoys entertaining others with his popular Fort Lauderdale Ghost Tour.

Visit us at
www.historypress.net